THEN & NOW

LOWER EAST SIDE

OPPOSITE: CHATHAM SQUARE, 1858. By the time this image was illustrated in 1858, Chatham Square had well over 200 years of modern history under its belt. This former Native American trail was home to the horse stables for America's first highway system, the Boston Post Road, and was transformed into an important livestock and farmers market by the mid-18th century. (Photograph courtesy of Pageant Book & Print Shop.)

LOWER EAST SIDE

Eric Ferrara with

David Bellel

Foreword by

Joyce Mendelsohn

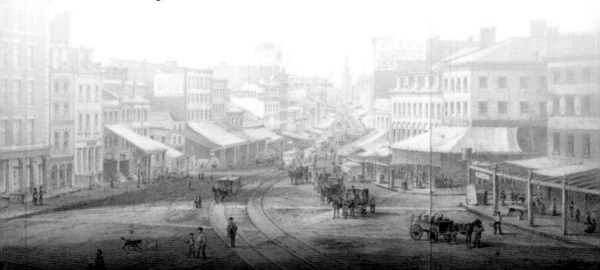

For all general information, please contact Arcadia Publishing:
Telephone 843-853-2070
Fax 843-853-0044
E-mail sales@arcadiapublishing.com
For customer service and orders:
Toll-Free 1-888-313-2665

Visit us on the Internet at www.arcadiapublishing.com

ON THE FRONT COVER: BOWERY AT GRAND STREET, 1915. Opened in 1878, the tracks of the IRT
Third Avenue Line elevated railway cast the Bowery into shadows and cemented the future of this
once illustrious thoroughfare. Now buried behind steel trusses, many once proud theaters, hotels,
and restaurants were forced to move, and the Bowery became a decidedly commercial district. (Then
photograph courtesy of New York Transit Museum, now photograph courtesy of Eric Ferrara.)

ON THE BACK COVER: MULBERRY AT MOSCO STREETS, C. 1900. Fresh, iced clams are being served up
from a wagon in what used to be part of the Little Italy district. Though clam and oyster peddlers were
once as common as hot dog vendors these days, one is more likely to find Chinese dumplings in this
neighborhood today. (Then photograph courtesy of Library of Congress, now photograph courtesy of
Eric Ferrara.)

CONTENTS

FOREWORD

We need to thank the burghers of the Dutch West India Company for creating the essential character of New York City—commerce, ethnic diversity, and upward mobility. They established the tiny trading post of New Amsterdam in 1625 on the tip of an island that the natives called Manahatta, with Belgian Walloons and French Huguenots as the first settlers. In the 1640s, a visitor to the thriving mercantile town counted 18 spoken languages, including Dutch, English, Portuguese, Spanish, French, German, Italian, the Munsee Delaware native dialect, and those of West Indian and African slaves. No buildings survive from that era.

We need to express our gratitude to generations of global immigrants who, fleeing from starvation, economic deprivation, or political and religious persecution, came to America seeking freedom and opportunity and put down roots on the Lower East Side. They were the majority of laborers who constructed tenements, mansions, churches, and synagogues, as well as commercial, government and cultural buildings, skyscrapers, and bridges that form the architectural legacy of our remarkable city.

The challenge in protecting this heritage is to maintain a reasonable balance between continuity and change. In 1965, the Landmarks Preservation Law, signed by Mayor Robert Wagner, set off an ongoing struggle with pro-preservation individuals, grassroots neighborhood groups, and citywide organizations pitted against the New York Real Estate Board, property owners, religious organizations, and rapacious developers represented by high-priced public relations firms lobbying community boards, elected officials, and the Landmarks Preservation Commission.

On the Lower East Side, gentrification is rapidly erasing our visible links with the past, replacing family-owned businesses with trendy shops and restaurants and low-rise affordable housing with luxury towers. Streetscapes are punctuated by incongruous intruders. Many of the neighborhood's oldest buildings face a precarious future.

This important, though heartbreaking, book reminds us of a tangible history that has vanished. The haunting photographs that researchers Eric Ferrara and David Bellel have discovered echo a prophetic line from a 1963 *New York Times* editorial, "And we will probably be judged not by the monuments we build, but by those we have destroyed."

—Joyce Mendelsohn, author,

The Lower East Side Remembered and Revisited (Columbia University Press, 2009)

ACKNOWLEDGMENTS

Special thanks go to Laura Kujo and Carey Strumm of the New York Transit Museum and to Dr. Joseph Scelsa and Kathleen Costantini at the Italian American Museum for their time and generous donations from the museums' archives.

We would also like to thank the following for their gracious contributions to this project: Shirley Dluginski, Paul Weissmann, Donald Loggins, Neal Hellman, Charles Raimondi, Murray Schefflin, Anthony Favazza, Pageant Book Shop of 69 East Fourth Street, Paul Charosh, Cezar Del Valle, Ralph Hittman, David Bellatoni, Flora J. Carnevale, Charlie Katz, Anne-Marie Clanton, Andi Sosin, Joel Sosinsky, and Joyce Mendelsohn.

All of the research herein was conducted by Eric Ferrara of Lower East Side History Project and David Bellel of the Knickerbocker Village blog.

Unless otherwise noted, then photographs are courtesy of the Library of Congress and now photographs are courtesy of Eric Ferrara.

INTRODUCTION

Place names are a peculiar matter in a constantly evolving city like New York. Stand on the corner of almost any block in Lower Manhattan these days and ask three passersby, "What neighborhood are we in?" and you will more than likely receive three entirely different yet legitimate responses. Or go ahead and ask my mother, a third-generation native Lower East Sider who moved out of the city in the 1980s, "Which way to NoHo?" and she would have no idea what you were talking about.

Before there was an East Village, Alphabet City, NoLita (North of Little Italy), BelDel (Below Delancey) or LiChi (Little Italy/Chinatown), Tribeca (Triangle Below Canal), NoHo (North of Houston Street), or SoHo (South of Houston Street), there was a Lower East Side and a Lower West Side.

These customized labels have been created by business owners, real estate professionals, and sometimes residents themselves in order to breathe new life into a neighborhood and, in the case of Lower Manhattan, disassociate the area from its working-class, immigrant past.

Today, many would consider the Lower East Side to be contained below Houston and Grand Streets, east of the Bowery. Traditionally, however, the district encompasses several neighborhoods like East Village, Alphabet City, NoLita, Little Italy, Chinatown, and Two Bridges.

This book covers the traditional geographical Lower East Side—rightfully famous as a longtime haven for the world's poor, tired, and huddled masses, a harbor for the discarded, oppressed, and abused, a cradle of the American melting pot, and a laboratory of contemporary social service, politics, and entertainment.

Today, under the crushing weight of gentrification, the Lower East Side is considered to be one of the most fashionable and hip addresses in America. After 150 years, aged tenements and multigenerational mom-and-pop stores have been transformed into four-star hotels, trendy nightclubs, and chic boutiques.

This book is dedicated to our ancestors of the Lower East Side, whose unbelievable sacrifices are largely forgotten today.

CHAPTER 1

WORTH STREET TO
GRAND STREET, WEST
OF THE BOWERY

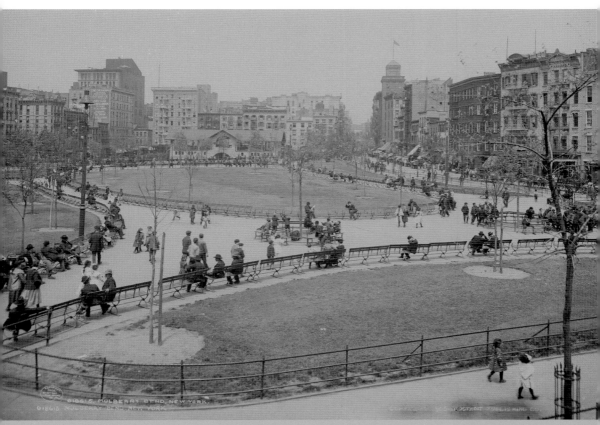

COLUMBUS PARK, C. 1905. A late-19th-century effort to sanitize some of New York City's most hazardous slums led to the razing of several acres of tenements in the old Five Points district. This photograph shows one result of this mass condemnation, an open-air green space referred to as Mulberry Bend Park, which opened in 1897. The name was changed to Columbus Park in 1911.

13

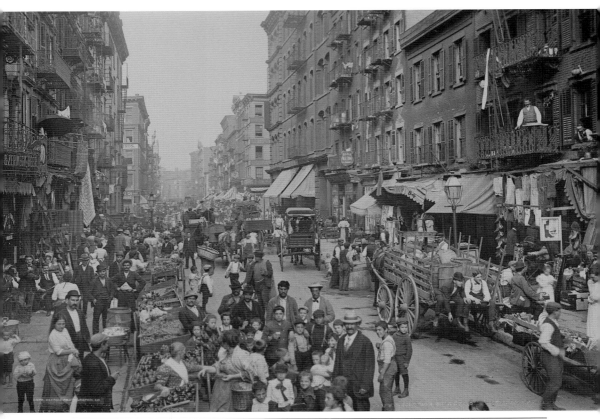

MULBERRY STREET, 1900. Pictured here is Mulberry Street facing north between Bayard and Canal Streets, so most of the subjects pictured are more than likely of Neapolitan decent. Little Italy, at the time, spanned Worth Street to Houston Street and was divvied up into several micro-neighborhoods. As a general rule, Neapolitans resided on Mulberry Street, Calabrians on Mott Street, and Sicilians on Elizabeth Street. Today, this area is part of the sprawling Chinatown district.

MOTT STREET, C. 1905. This photograph shows what appears to be a funeral procession through early Chinatown, as horses in full dress pull carriages with flowered crosses past the Wing Tong Novelty store at 5 Mott Street, which shares the address with the Imperial restaurant on the second floor. More than likely, the caravan is leaving a ceremony at the Church of the Transfiguration, seen in the background on the far right.

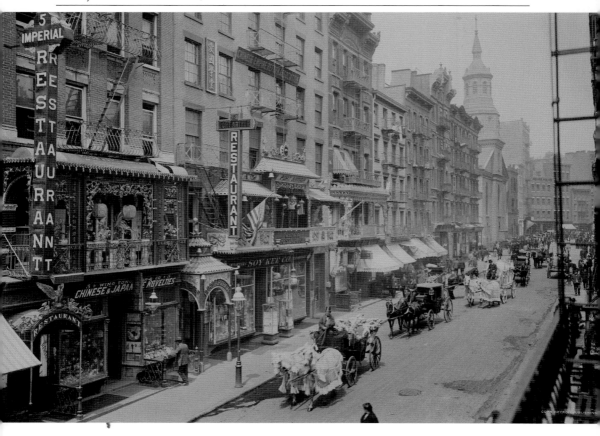

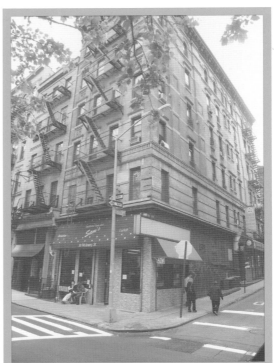

TAVERN AT 30 MULBERRY STREET, 1895.
The Black Horse Tavern was erected on
this corner in the early 19th century when
Mosco Street was still known as Park
Street. Located just a stone's throw from
the infamous intersection known as Five
Points, the tavern served the local Irish and
black communities until Southern Italians
began arriving in the 1870s to displace
them. It was, in fact, an Italian banker in
1899 who developed the building seen
today. (Then photograph courtesy of New
York Transit Museum.)

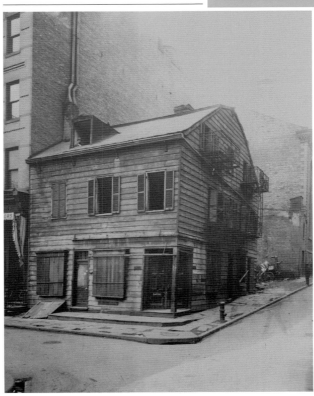

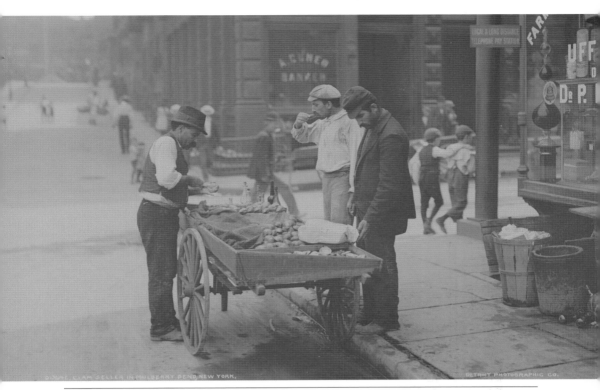

MULBERRY AT MOSCO STREETS, C. 1900. Seen here at the corner of Mulberry and Mosco Streets, some Italian men enjoy iced raw clams from a street peddler in front of a *farmacia* (pharmacy). On the northeast corner stands the A. Cuneo Bank, built in 1899 on the site of the Black Horse Tavern by Antonio Cuneo, who began his career in America as a street peddler.

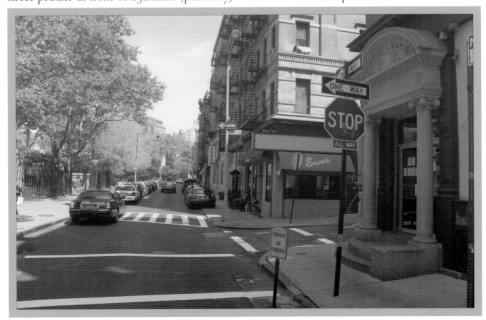

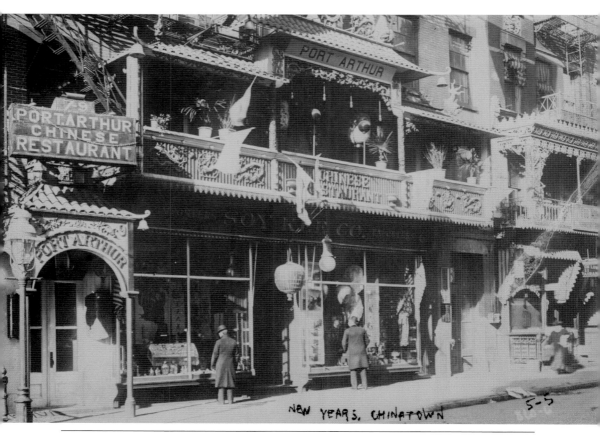

NEW YEARS, CHINATOWN 5-5

RESTAURANT AT 7–9 MOTT STREET. The Port Arthur was a popular 20th-century Chinese restaurant founded by a man named Cho Gum Fai. Chu Ho purchased the restaurant in the 1920s and made several improvements, including the installation of Chinatown's first escalator. The restaurant hosted countless weddings, civic meetings, and political balls until closing its doors in 1979. The building has recently undergone a complete renovation.

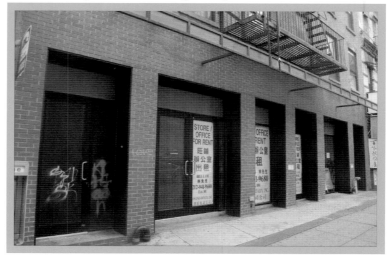

GAMBLING AT 10 MOTT STREET, 1909.
Two decades before this 1909 photograph was taken, 10 Mott Street sheltered one of 21 known fan-tan gambling parlors on this single block between Bowery and Mosco Street. Over the following century, several Chinese eateries had called this building home, including the Portland (pictured) and the Three Star. By the late 1980s, the storefront housed a family-friendly arcade where the main attraction was Birdbrain, a live chicken that played tic-tac-toe.

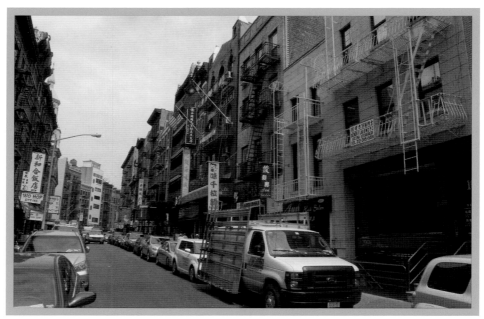

MOTT STREET, 1911. Above Boston Cigars at 12 Mott Street, where the American and Chinese flags are displayed, is the Young China Association headquarters in 1911 (tagged as "Chinese Revolutionary Headquarters" in the original photograph). Next door is the Flowery Kingdom Restaurant at 14 Mott Street, and above that are the former offices of the Chinese Merchant's Association, which has since moved to 83 Mott Street.

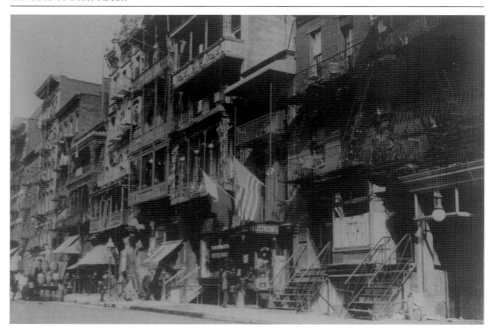

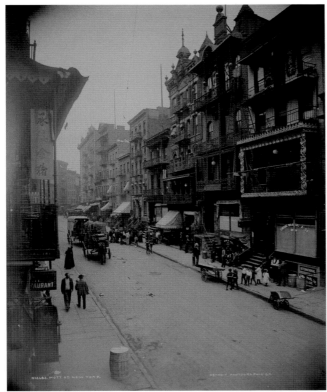

MOTT STREET, C. 1900. Another east side view of Mott Street shows the Kwong Wah Tai restaurant at 14 Mott Street and what appear to be three restaurants crammed into the structure at 16 Mott Street: Chung Wu & Co. in the sub-floor, Mee King Lun & Co. on the first floor, and King Hong Lau & Co. on the second floor. Today, 16 Mott Street is the headquarters of the Taiwanese Benevolent Society for Citizens of New York.

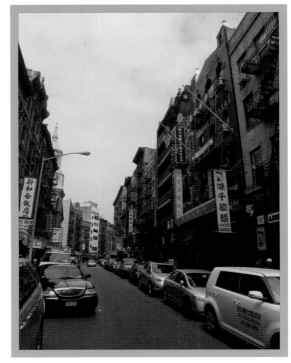

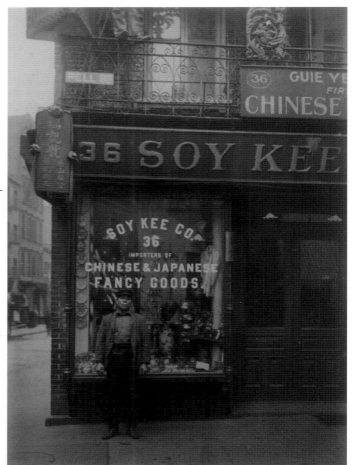

BUSINESS AT 36 PELL STREET, 1903. Pictured here is the Soy Kee Company, importers and exporters of fine Asian goods, founded in the 1880s by Chu Ho. Eventually, Soy Kee moved to a former stable at 7–9 Mott Street, below the Port Arthur Restaurant, which Chu Ho would purchase in the 1920s. The Mon Fong Wo Chinese grocery was opened at 36 Pell Street by the Leong family soon after Soy Kee left, and operated at this location until the late 1970s.

CORNER OF MOTT AND PELL STREETS, C. 1903. In this photograph, a worker performs maintenance on the balcony of the second-floor Guie Yee Quen restaurant, just above the Soy Kee goods store at 36 Pell Street. The sign on the corner states, "American Trade Solicited." Next door at 34 Pell Street is the Chong & Co. Grocery store with what appears to be fine china plate sets in the window. Today, an optician and dentist occupy 36 Pell Street, and a restaurant is located at 34 Pell Street.

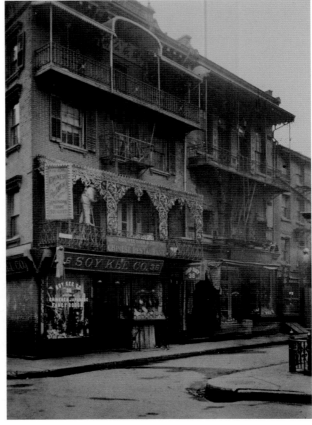

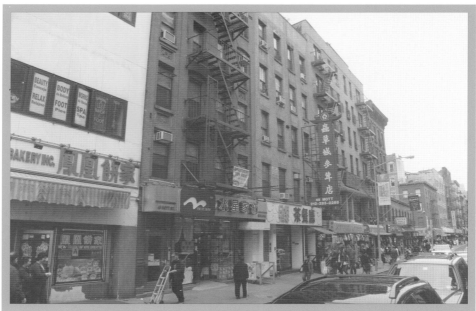

MOTT STREET, 1964. According to the original caption, these are four "Americanized Chinese girls" crossing Mott Street in 1964. Behind them is the Pagoda Restaurant & Bar at 41 Mott Street and another restaurant with the peculiar name of the Chinese Rathskeller. Though most of the building has been completely renovated, 41 Mott Street still boasts what is said to be the last wooden pagoda roof in New York City.

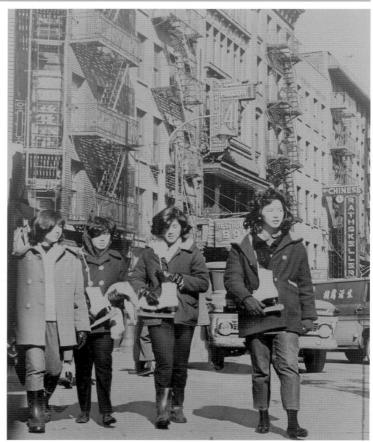

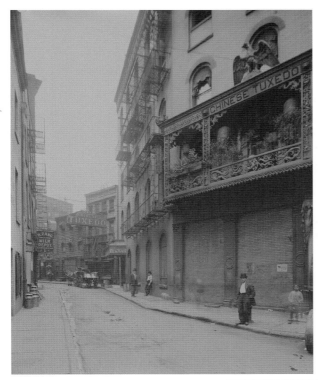

LOCATED AT 2 DOYERS STREET, 1910S. By the turn of the century, Chinatown was a small community consisting of perhaps hundreds of Chinese residents. Many of the businesses at the time, like the Chinese Tuxedo restaurant pictured here at the corner of the Bowery, were a popular destination for Western patrons eager for a glimpse at the "exotic" Far East. Chinese Tuxedo closed its doors by the 1920s, and all of its exterior décor was lost forever. Today, the address hosts a Chase bank.

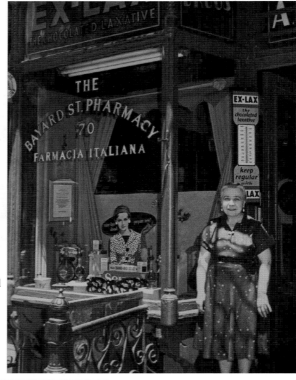

PHARMACY AT 70 BAYARD STREET, 1960s. Standing in front of this *farmacia italiana* (Italian pharmacy) at 70 Bayard Street is longtime proprietor Assunta Cirota, who won a celebrated legal case in 1970 against a landlord who attempted to raise her rent from $400 to $2,000 a month. The rent hike was deemed "arbitrary and unconscionable" by the courts, and a more amicable $525 per month was awarded. In the modern photograph, the store is under construction. Today, the storefront hosts a watch repair shop. (Then photograph courtesy of Italian American Museum.)

FISH MARKET AT 71 MULBERRY STREET. From left to right in this early-century photograph are Joe "Fish" Arbucci, Jimmy "Fish" Arbucci, and "Uncle Luigi" Arbucci of the family-operated Arbucci Fish Market. On the far right is Hymie Ressler, proprietor of a grocery store at 71 1/2 Mulberry Street. Remarkably, a fish market and grocery still remain at these addresses, only now the businesses are Chinese owned. (Then photograph courtesy of Italian American Museum.)

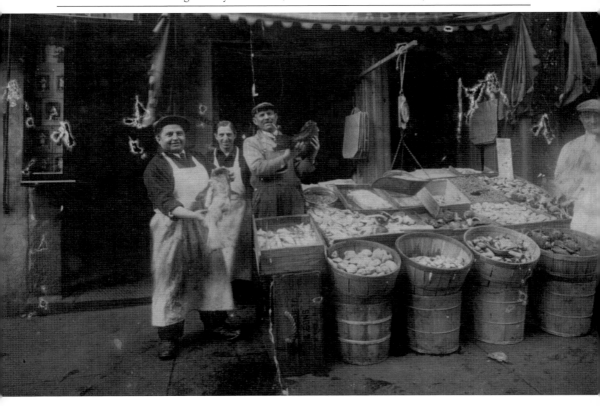

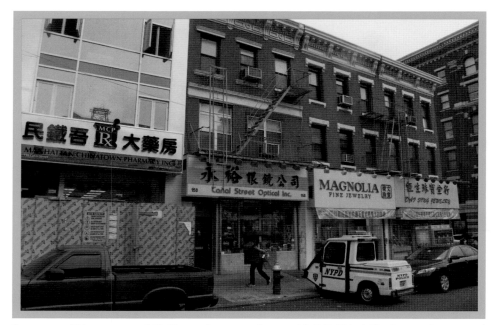

STORES AT 154 THROUGH 160 CANAL STREET, 1910. Pictured on the far left is the S. Wolarsky & Son garment store at 154 Canal Street, and next door is the former White House Hotel. N. Shapiro & Sons Sign Company shares 158 Canal Street with B.S. Kahn's "hosiery, underwear and knit goods" store, and 160 Canal Street hosts Pelz's "Cotton Goods." This entire block has been completely redeveloped.

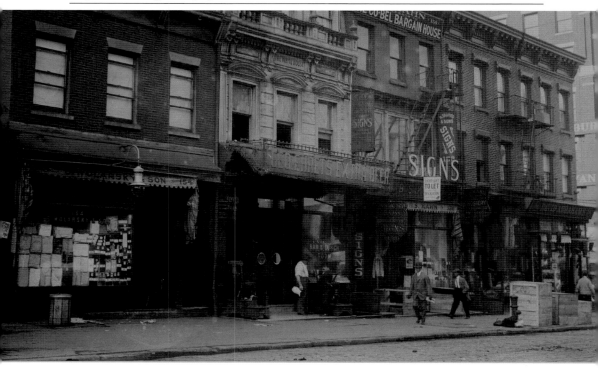

WORTH STREET TO GRAND STREET, WEST OF THE BOWERY

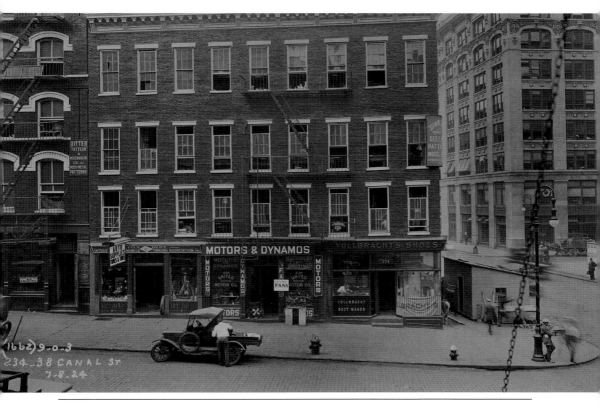

BUSINESSES AT 234 THROUGH 238 CENTRE STREET, 1924. Pictured here on the southeast corner of Canal and Centre Streets is an early auto-supply shop, Interstate Mobile Owners Association at 234 Centre Street. Next door, the United Electric Motor Company is selling and repairing small motors and dynamos at 236 Centre Street and on the corner is a German boot maker's shop, Vollbracht's Shoes, at 238 Centre Street. Today, 234–238 Canal Street has been replaced by a two-story building that houses a Chinese market. (Then photograph courtesy of New York Transit Museum.)

**CANAL STREET AT BOWERY,
1923.** The domed structure
at the corner of Bowery
and Canal Street, still
under construction at the
time of this photograph,
was completed in 1924
for the Citizen's Savings
Bank. Today, the bank
belongs to HSBC. This is
also the 18th-century site
of the White Horse Tavern,
where George Washington
stopped for a drink as the
British allies evacuated
Manhattan after the
Revolutionary War. (Then
photograph courtesy of
New York Transit Museum.)

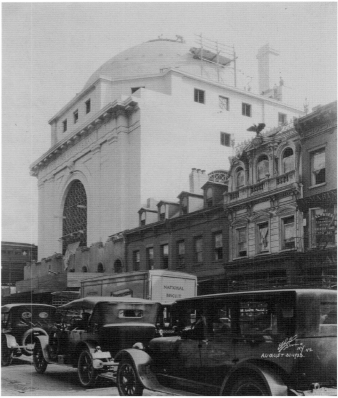

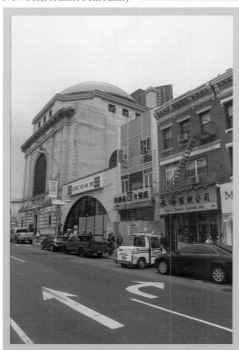

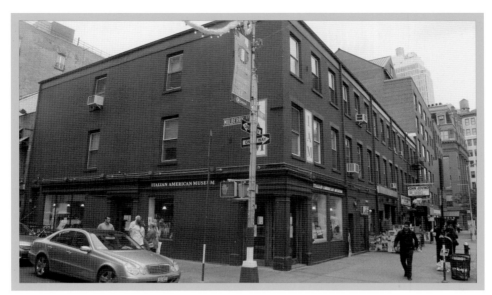

BANK AT 155 MULBERRY STREET, LATE 19TH CENTURY. Founded in 1882, Banco Stabile served the Italian immigrant community for a half century until 1932, when it merged with Banca Commerciale Italiana Trust Company. More than a place to deposit money, these institutions provided valuable translation services, sold steamship tickets, and wired telegrams. The bank was still intact when, in 2006, ancestors of founder Francesco Stabile sold the building to the Italian American Museum, which now calls the address home. (Then photograph courtesy of Italian American Museum.)

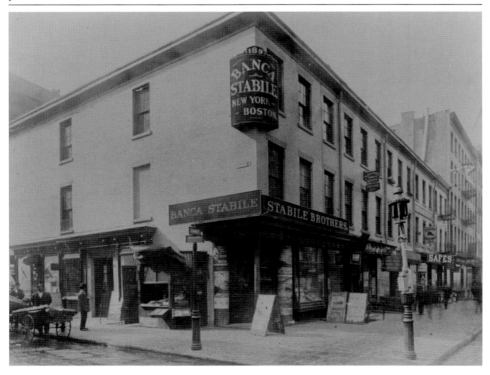

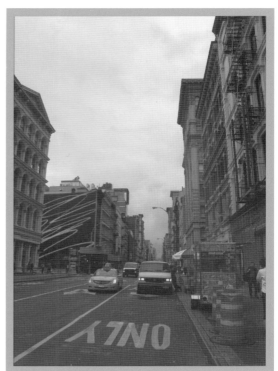

CANAL STREET AT BROADWAY, 1916.
Horse-drawn carriages and trolley cars
dot the avenue in this early-century
photograph, taken on Broadway just north
of Canal Street; however, within just a
few short years, automobiles would share
the streets for a short time before quickly
replacing these now antiquated modes
of transportation. Today, Broadway is
congested with foot and vehicular traffic
nearly 24 hours a day.

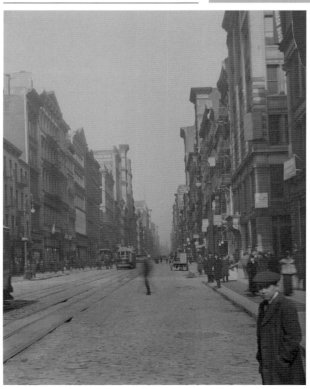

CHAPTER

BROOKLYN BRIDGE TO GRAND STREET, EAST OF THE BOWERY

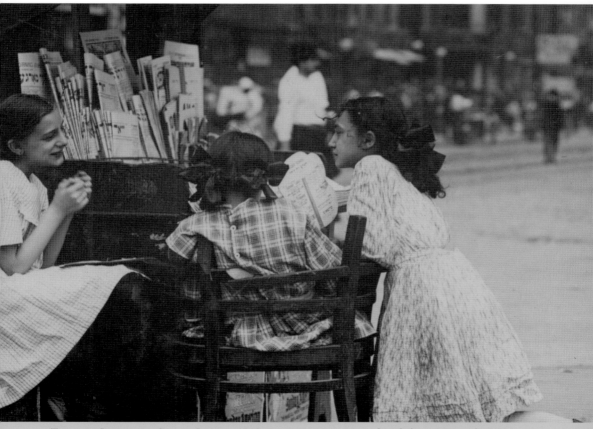

TENDING STAND ON CANAL STREET, 1910. In this early-century photograph, three young girls operate a Yiddish-language newspaper stand. One of the papers on display is *Der Morgen Zhurnal* (the *Morning Journal*), founded in 1901 on the Bowery by Jacob Sapirstein. It was the most popular daily of the era that catered to the conservative Jewish immigrant population.

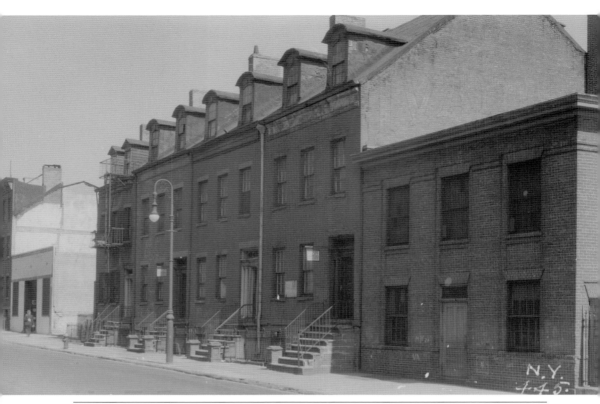

LOCATED AT 329 CHERRY STREET, 1910. Built on land that was originally part of the Henry Rutgers farm, the property was divided, and the lot was acquired by his willed heir Mary McCrea. She, in turn, leased it to George Fordham, who built this house in 1831. The properties on this site were later demolished, and the John L. Bernstein Elementary School was built here in 1965. It is now known as PS 184. (Now photograph courtesy of Shirley Dluginski.)

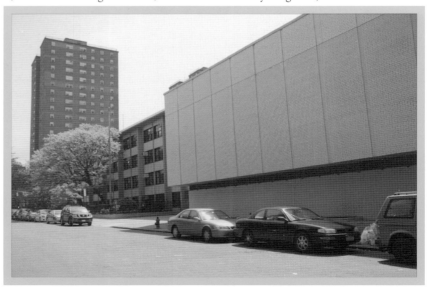

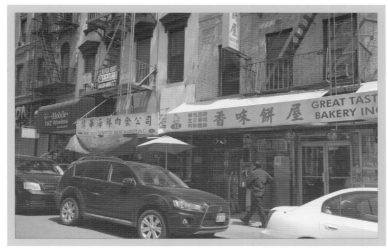

BAKERY AT 35 CATHERINE STREET, LATE 1970S. This image features the once popular Savoia's bakery, owned by Anthony Favazza. Favazza, who started working there in 1940, states, "I think the name Savoia comes from the original owner Michael Piccolo. He used to work at the Hotel Savoy as a baker." Currently, a Chinese bakery occupies the premises. (Then photograph courtesy of Anthony Favazza, now photograph courtesy of Shirley Dluginski.)

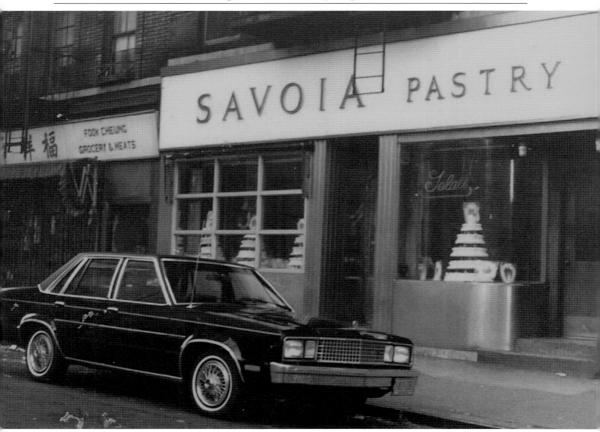

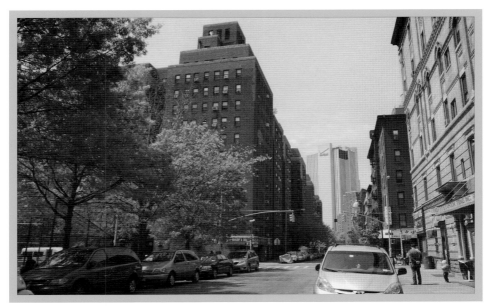

MARKET AT MONROE STREETS, FACING WEST, 1967. On the left of this photograph is PS 177, which is in the process of being demolished. The school was built in 1899 to help accommodate the ever-increasing number of school-age immigrant children in the Fourth Ward neighborhood. The school got some relief with the razing of the nearby densely populated tenements and the building of Knickerbocker Village in 1934. (Then photograph courtesy of Murray Schefflin, now photograph courtesy of Shirley Dluginski.)

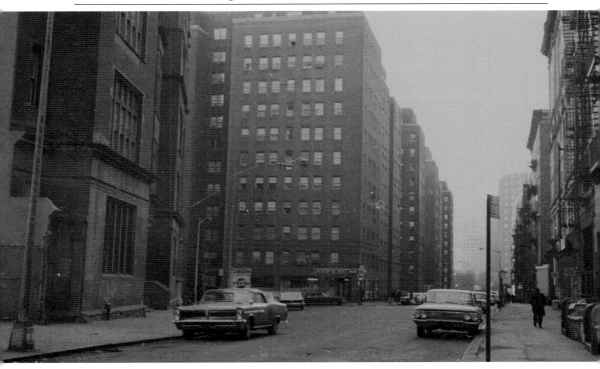

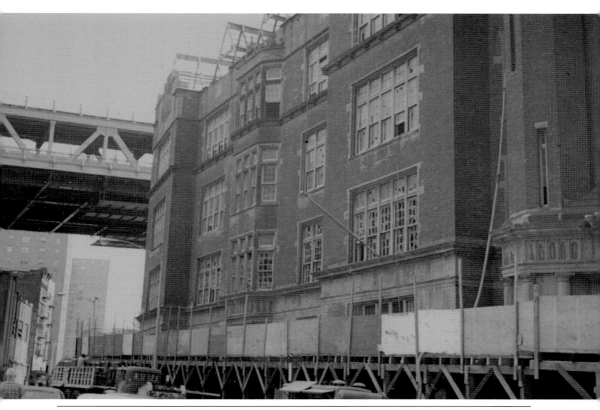

MARKET AT MONROE STREETS, FACING EAST, 1967. With the doomed PS 177 on the right, the Manhattan Bridge is overhead, and two of the five Rutgers Houses buildings are visible beyond Pike Street. Built in 1965, they replaced tenements on land that had formerly been part of Henry Rutgers's farm. Now, the area is home to a baseball field and a skateboard park. (Then photograph courtesy of Murray Schefflin, now photograph courtesy of Shirley Dluginski.)

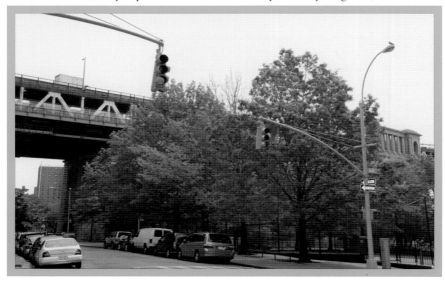

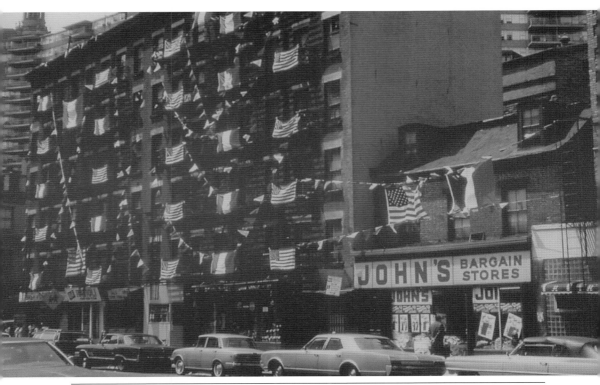

MADISON STREET BETWEEN JAMES AND OLIVER STREETS, 1980. Beyond the storefronts, not much has changed structurally since this photograph was taken in 1980; in fact, not much has changed in over a century. The three-story building to the right (47–49 Madison Street) still stands and may even predate the Madison Street name. Originally called Bancker Street in honor of a Rutgers family in-law, the name was changed in 1826 when the neighborhood became less desirable. (Then photograph courtesy of Charles Raimondi, now photograph courtesy of Shirley Dluginski.)

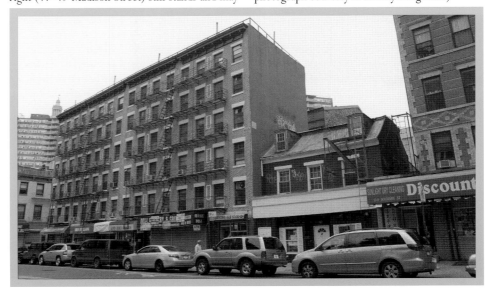

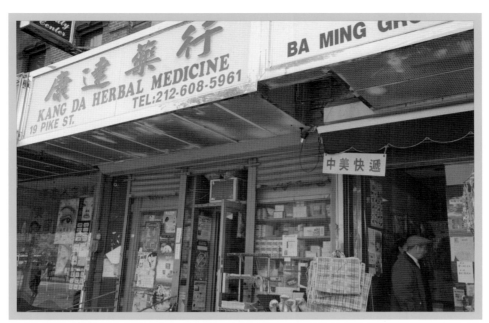

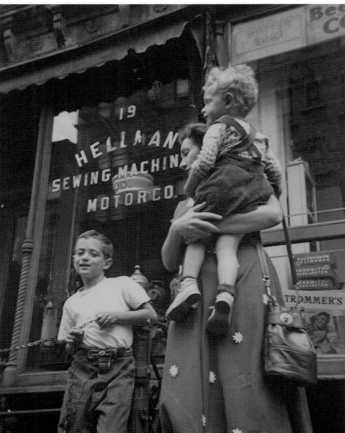

BUSINESS AT 19 PIKE STREET, 1950S. This photograph features Molly Hellman and sons Billy and Neal in front of husband Sol's sewing machine and motor repair shop. The grocery store next door displays a sign for Trommer's beer, which was a popular "all-malt" beer brewed in Bushwick, Brooklyn, at one time. The machine shop has since been transformed into a Chinese herbal medicine store. (Then photograph courtesy of Neal Hellman, now photograph courtesy of Shirley Dluginski.)

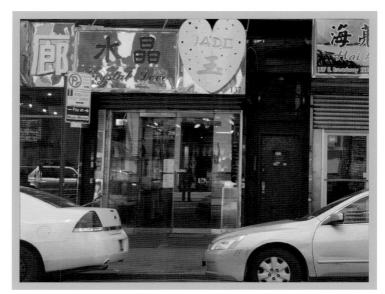

LOCATED AT 137 EAST BROADWAY, 1908. The original caption attached to this image is "Jews taking home free motzohs." When this photograph was taken, 137 East Broadway did in fact house mainly Jewish immigrants from Russia. Today the building is virtually unchanged, though most likely the inhabitants are recent immigrants from China. A modern tea parlor and jewelry store now populate the ground floor. (Now photograph courtesy of Shirley Dluginski.)

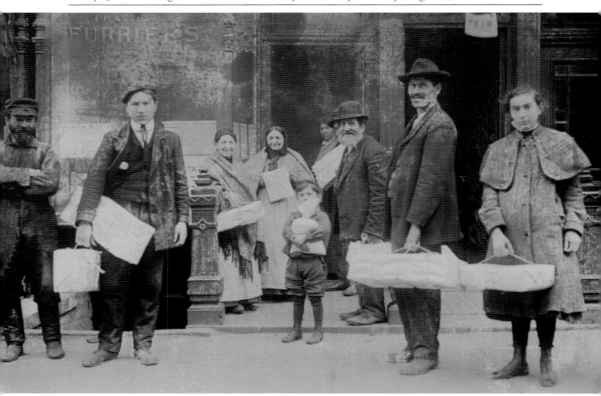

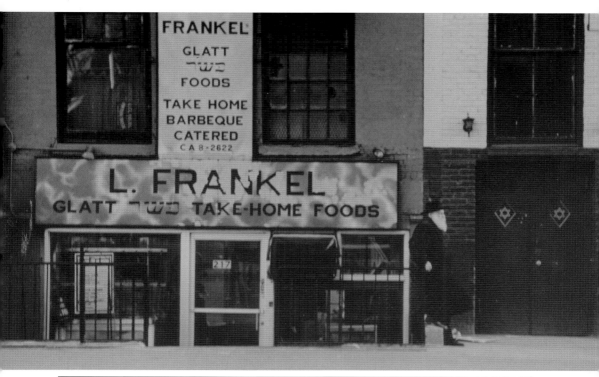

STORE AT 217 EAST BROADWAY, 1970S. East Broadway was for many years popular for its numerous and *shtieblachs* (small congregations), though its long Jew-centric history has largely disappeared over the last couple of decades due to the expansion of Chinatown. The street's former Orthodox Jewish nature is reflected in this photograph of L. Frankel's Glatt Kosher foods, now occupied by Dumpling Town. (Then and now photographs courtesy of Paul Weissman.)

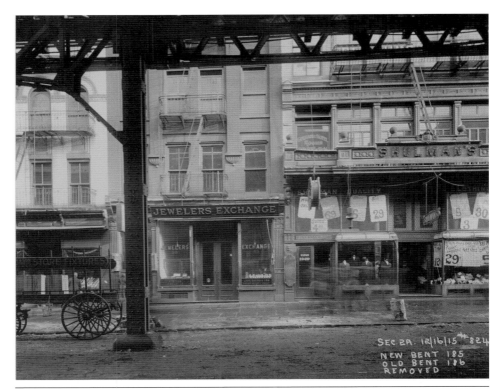

LOCATED AT 81 AND 83 BOWERY, 1915. At the time this photograph was taken, 83 Bowery was home to J. Goldberg & Son Jewelers; today, it is home to a Chinese cosmetic store. Next door at 81 Bowery was Shulman's clothing store, established in 1886, and the Germania Hotel, which advertised rooms for 25¢. Today, the address still hosts a low-rent lodging house with a sign in English and Chinese. (Then photograph courtesy of New York Transit Museum, now photograph courtesy of Shirley Dluginski.)

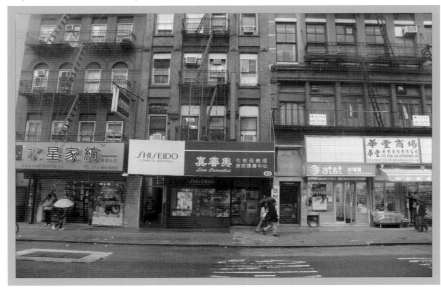

SEWARD PARK, C. 1910. Built at a cost of $2 million in 1903, Seward Park was considered at the time to be one of the best-equipped public playgrounds in the world. Here, some young girls from cramped local tenements release pent-up energy playing tether. Today, the park still plays an important role in the lives of neighborhood children, though many of the surrounding structures have been redeveloped. (Now photograph courtesy of Shirley Dluginski.)

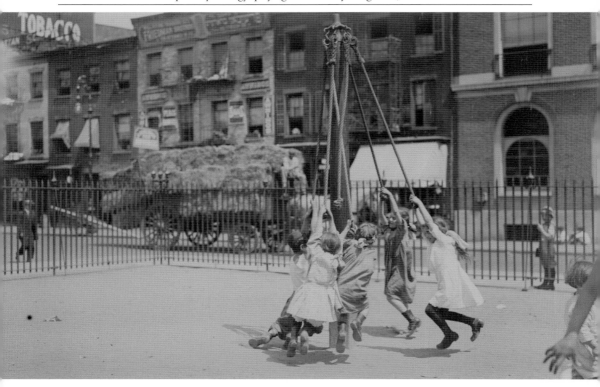

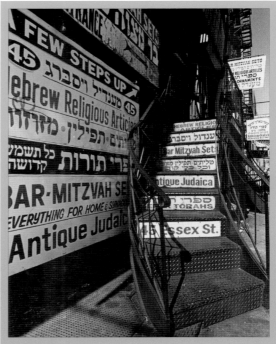

SHOP AT 45 ESSEX STREET, 1970s. This photograph features two unique spiral metal staircases that extend from the mezzanine landing of Weisberg's Judaica store. In both English and Hebrew, each step advertises the store's wares, such as "Bar-Mitzvah Sets" and "Antique Judaica." Years ago, many such stores populated this two-block stretch between Canal and Grand Streets, though today, most have disappeared. (Then and now photographs courtesy of Paul Weissman.)

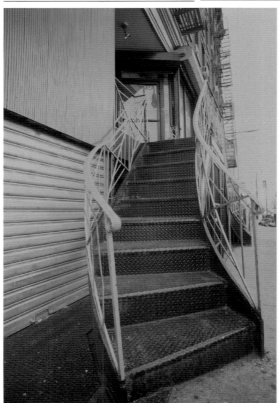

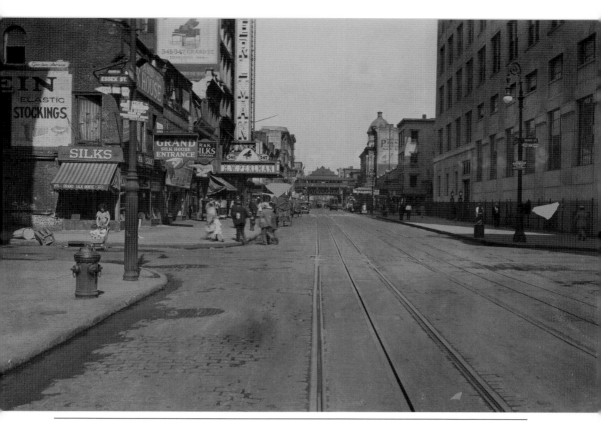

GRAND STREET AT ESSEX STREET, 1930. This unique image offers a glimpse of what was the intersection of Grand and Essex Streets, facing west, before Essex was widened later that decade. In the distance is the First Avenue Line elevated railway along Allen Street, and to the right is Seward Park High School. The buildings in view have remained relatively the same to this day. (Then photograph courtesy of New York Transit Museum.)

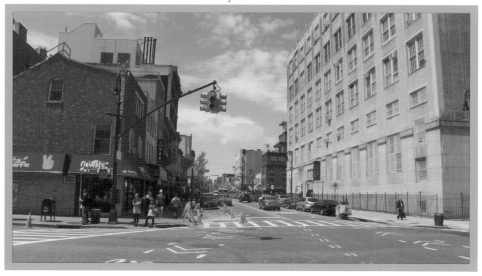

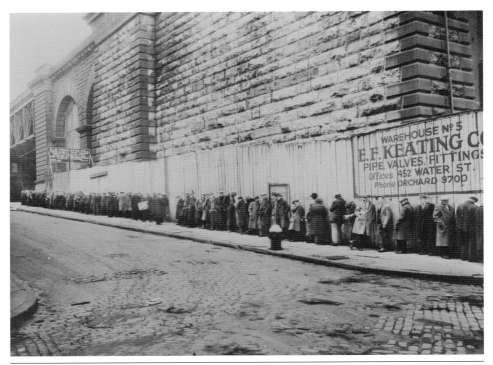

BROOKLYN BRIDGE, 1931. By 1931, there were at least 80 city-organized breadlines in Manhattan serving over 80,000 meals a day. By October of that year, a central bureau was created to register applicants in order to curb gouging and ensure New York residents were fed first and foremost. Today, the 32-story Verizon Building is visible behind the bridge at 375 Pearl Street, and Fishbridge Park can be seen in the foreground. (Now photograph courtesy of David Bellel.)

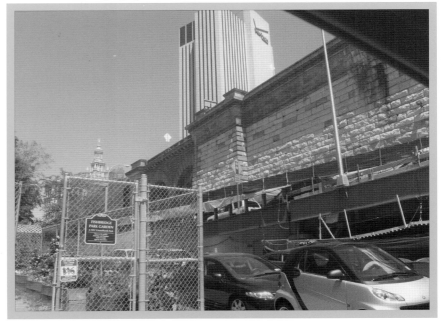

CHAPTER

GRAND STREET TO HOUSTON STREET, WEST OF THE BOWERY

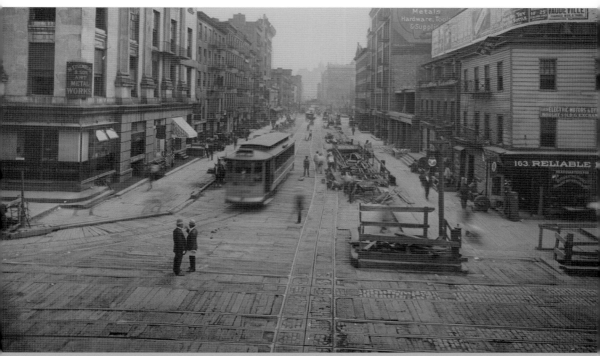

GRAND AT CENTRE STREETS, 1909. This unique 1909 photograph facing north on Centre Street from Grand Street shows a bygone era of the Lower East Side when utilitarian needs trumped aesthetics. Long planks of wood and uneven cobblestone cover just about every inch of this intersection, including sidewalks. Two men hold a conversation in the middle of the street as a trolley car is about to whip past them. (Then photograph courtesy of New York Transit Museum.)

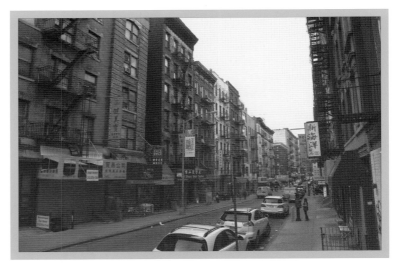

BUSINESSES AT 156 THROUGH 168 MOTT STREET. From left to right in this early-1900s photograph are Cianciosi Bianchieri (bankers) at 168 Mott Street, Raffaele Venezia Cafe, Candy & Cigar store at 166, a *grosseria* (grocery store) at 164, a *levatrice* (midwife) office at 162, a shoe repair and dry goods store at 160, a *farmacia* (pharmacy) at 158, and a saloon named Oriental Hall at 156. Today, a row of Chinese businesses lines the block.

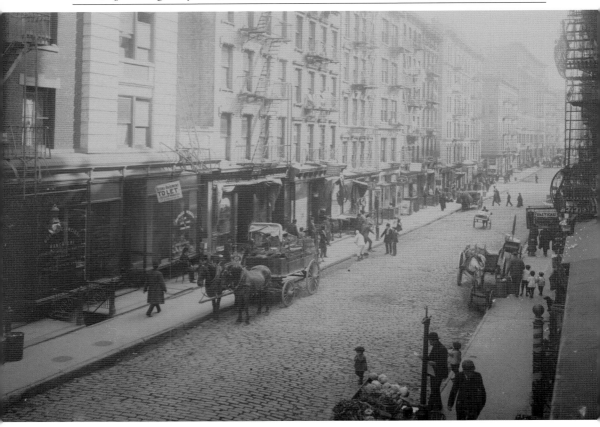

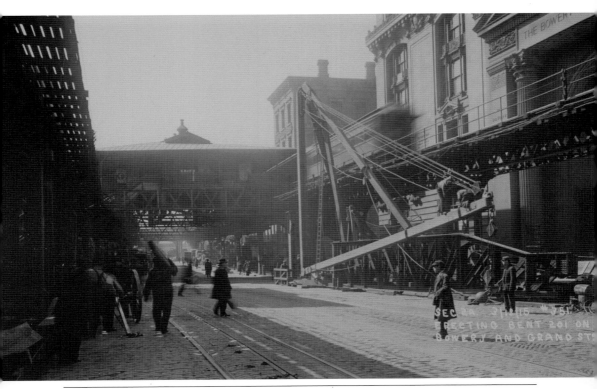

Bowery at Grand Street, 1915. Erected in 1878, the famous Third Avenue El (short for "elevated railway") roared up and down the Bowery and Third Avenue from Chatham Square to Gun Hill Road in the Bronx for nearly a century, until dismantled in 1955. In this photograph, some work is being done on the tracks just north of the Grand Street station as a train rumbles past the Bowery Savings Bank, which is utilized as a nightclub and event hall today. (Then photograph courtesy of New York Transit Museum.)

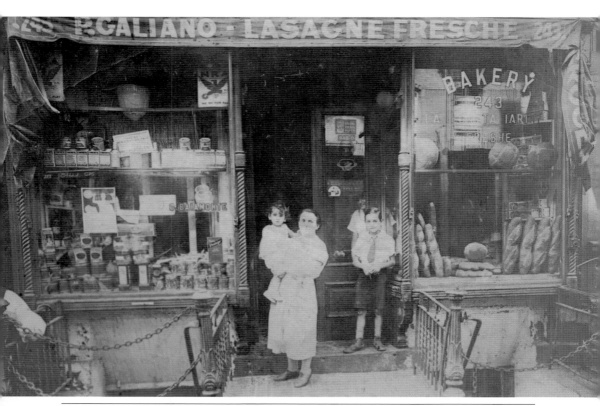

BAKERY AT 243 MULBERRY STREET. Standing out front of the P. Galiano Italian Bakery is Gierlanda Galiano with her baby Anna and two young sons Michael and Gaetano in the doorway. Displayed in the windows are cans of tomato sauce and oils on the left side and baked breads on right side. The awning reads, "*Lasagne Fresche*" (Fresh Lasagna). Today, a delicatessen occupies the storefront. (Then photograph courtesy of Italian American Museum.)

BANK AT 240 ELIZABETH STREET, 1908. Founded in 1891, Pati's Bank flaunted its status as the most prominent bank in the Italian quarter by displaying over $30,000 in bills and gold coins in its barred storefront window. In this photograph, police guard the bank after owner Pasquale Pati, once known as the "J.P. Morgan of Little Italy," fled New York with his family after several threats on his life by the local Black Hand. Today, the address hosts a clothing boutique.

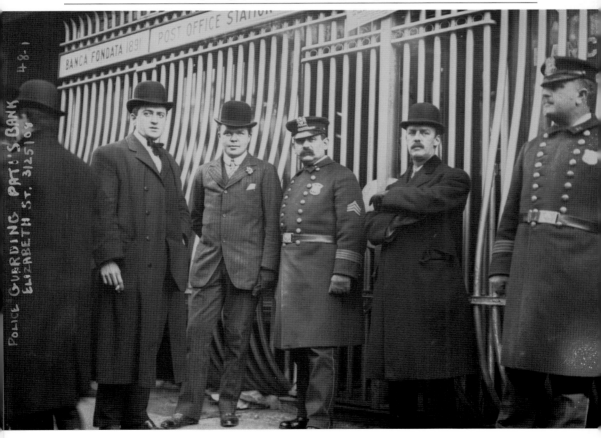

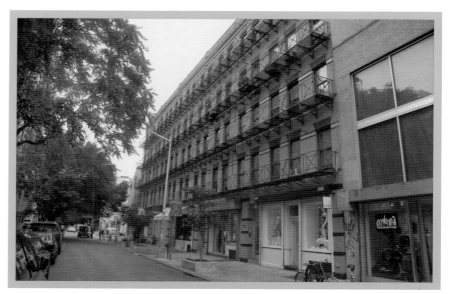

STRUCTURE AT 260–266 ELIZABETH STREET, 1912. This row of tenements sits at the very northern edge of what was once considered New York City's Little Italy tenement district, which at one time contained a massive swath of real estate between Worth Street and Houston Street. Today, 260–266 Elizabeth Street is a fully renovated residential apartment building with upscale boutiques and eateries occupying the storefronts.

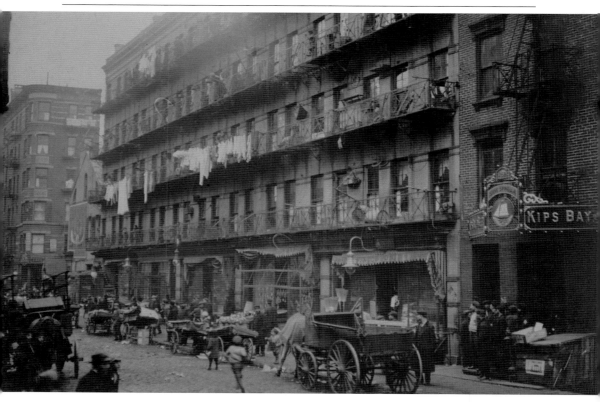

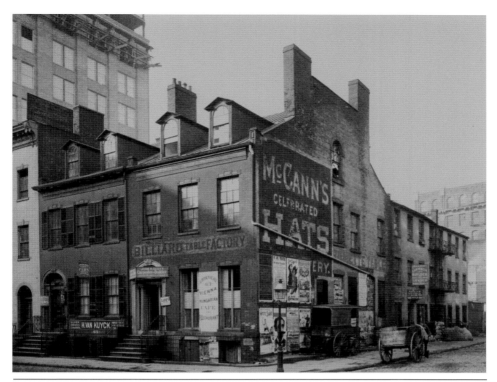

LOCATED AT 63 PRINCE STREET, 1896. This building at 63 Prince Street was the former home of Pres. James Monroe, who died here on July 4, 1831. Constructed at the corner of Lafayette Street in 1823 by Monroe's son-in-law Samuel L. Gouverneur, the two-and-a-half- story brick house was sold in 1919 along with several surrounding lots to the C & M Envelope Company, which had it demolished to make way for a factory. (Then photograph courtesy of New York Transit Museum.)

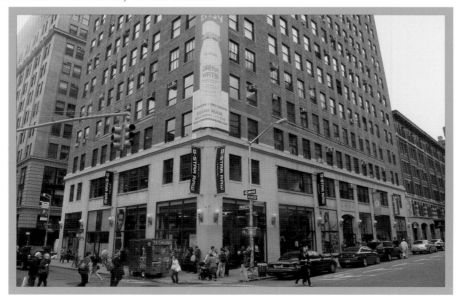

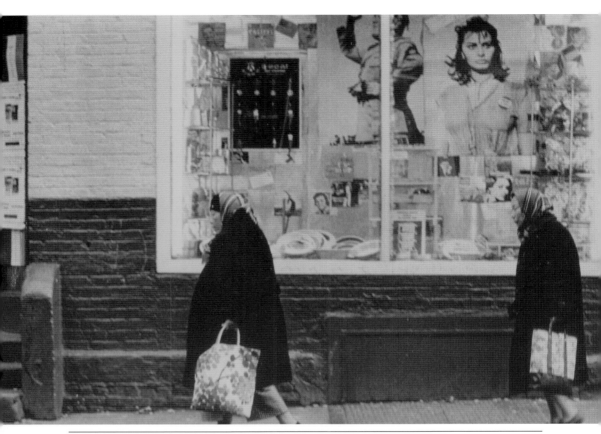

STORE AT 58 ELIZABETH STREET, 1970S. In this photograph, two elderly Asian women walk north towards Hester Street past what looks like an Italian home goods store at 58 Elizabeth Street. In the storefront window are a famous poster of Sophia Loren from the 1957 film *Boy on a Dolphin* and another poster of Benito Mussolini. Today, the same location reflects the shifting demographics of the neighborhood as the storefront now hosts a Chinese jeweler. (Then and now photographs courtesy of Paul Weissman.)

CHAPTER 4

Grand Street to Houston Street, East of the Bowery

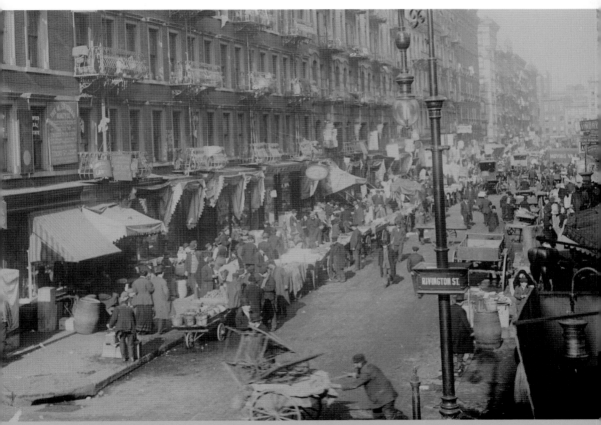

ORCHARD AT RIVINGTON STREETS, 1909. This snapshot of the iconic Orchard Street, marked as "the Ghetto" in the original caption, shows how just about every inch of the neighborhood was utilized at the turn of the century. Crammed into storefronts behind blocks of street vendors are dozens of offices and services such as realtors, lawyers, movers, launderers, and dressmakers.

ESSEX MARKET COURTHOUSE, 1892. The Essex Market Court, erected in 1856, was located on Essex Street between Grand and Broome Streets right next door to the legendary Ludlow Street Jail, which can be seen to the left in this photograph. The court was demolished in 1908 and soon relocated to Second Avenue and Second Street. Seward Park High School now sits on this site. (Then photograph courtesy of New York Transit Museum.)

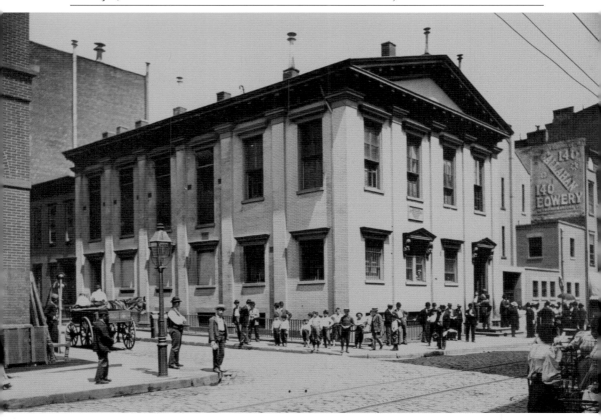

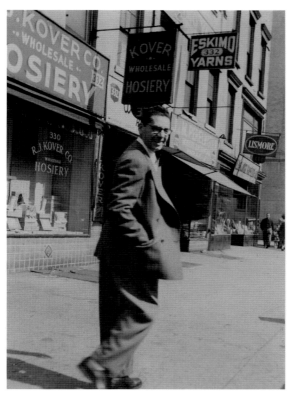

BUSINESSES AT 330 THROUGH 334 GRAND STREET, 1948. In this image, author David Bellel's father Sol walks toward Lismore's Hosiery at 334 Grand Street, passing by Kover Hosiery at 330 and Eskimo Yarns at 332. Lismore's was located at the corner of Ludlow for 68 years until closing in 2005. Soon after, the address was completely remodeled into a condominium. (Then photograph courtesy of David Bellel.)

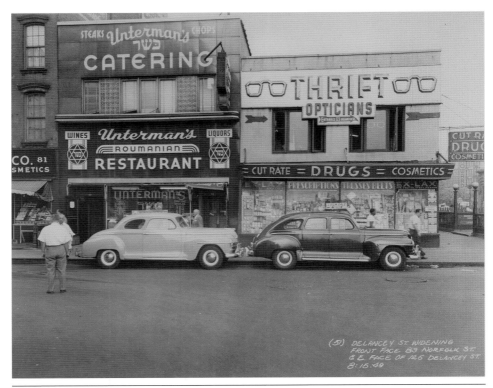

Handwritten on photograph: (51) DELANCEY ST. WIDENING / FRONT FACE 83 NORFOLK ST. / & E. FACE OF 125 DELANCEY ST. / 8:15:49

RESTAURANT AT 83 NORFOLK STREET, 1949. Located on the southwest corner of Delancey Street, Unterman's Roumanian Restaurant was just one of several similar styled eateries in the immediate area when this photograph was taken in 1949. Gluckstern's was around the corner at 135 Delancey Street, and Pollack's was on the east side of Norfolk Street. By the 1970s, several lots at this intersection were demolished, and the land has yet to be developed. (Then photograph courtesy of New York Transit Museum, now photograph courtesy of Shirley Dluginski.)

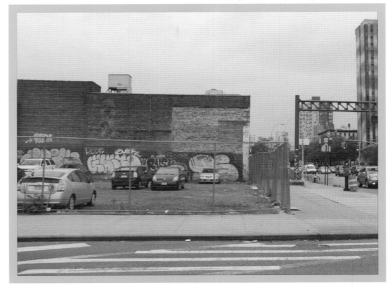

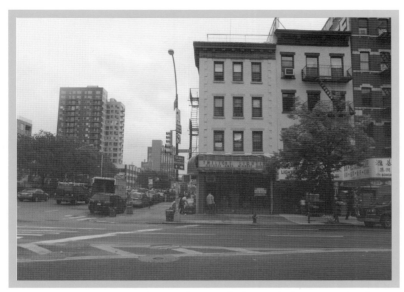

HOTEL AT 173 BOWERY, 1915. Pictured here on the southwest corner of Bowery and Delancey Street is the former Bridge Hotel, appropriately named since the Williamsburg Bridge is just a few blocks east. Parked in front of the hotel is a horse and carriage delivering the *Globe* evening newspaper, with the words "Largest High Class Circulation" painted on the side. Today, the storefront is empty since a longtime light and fixture retailer moved out. (Then photograph courtesy of New York Transit Museum.)

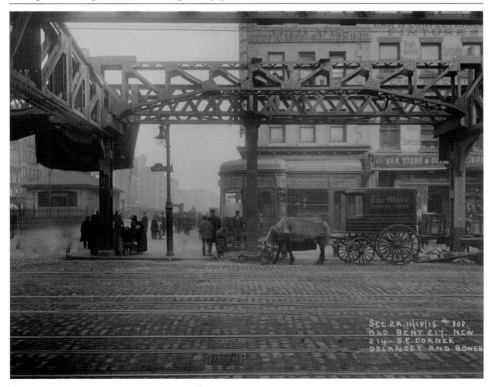

DELANCEY AT CHRYSTIE STREETS, 1949. During the 1948 widening of Delancey Street, a pedestrian mall and several transportation kiosks between the Bowery and the Williamsburg Bridge were demolished. The building in the center of this photograph, which faces west towards the Bowery, once sat above an underground trolley terminal. The building is long gone, but the terminal is currently being designed for an underground park called the Low Line. (Then photograph courtesy of New York Transit Museum.)

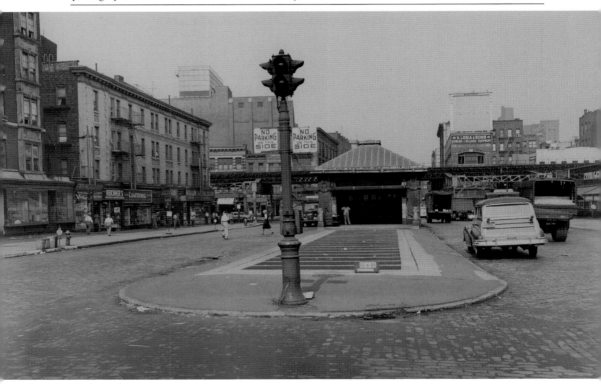

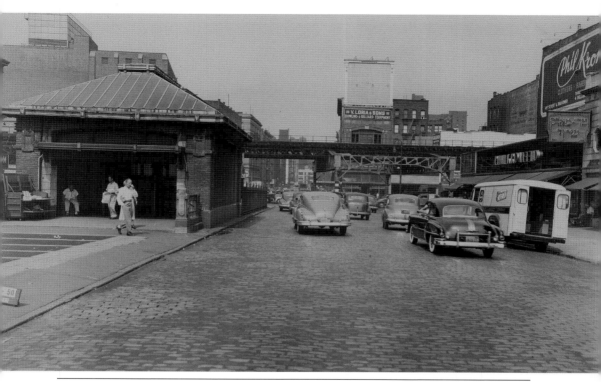

DELANCEY STREET AT BOWERY, 1949. This photograph offers a closer look at the trolley station that once sat in the middle of Delancey Street. To the right of this image on the north side of the street is Phil Kronfeld's at 4 Delancey Street. Kronfeld was a famed haberdasher whose electrified storefront sign was declared a landmark. That store relocated uptown shortly after this image was captured. (Then photograph courtesy of New York Transit Museum.)

GRAND STREET TO HOUSTON STREET, EAST OF THE BOWERY

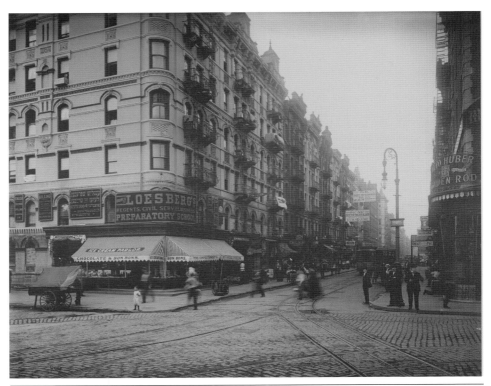

NORTHEAST CORNER OF DELANCEY STREET AT CLINTON STREET, 1906. Featured in this photograph is the former 164 Delancey Street, home to Loesberg's Preparatory School, which offered help preparing for highly desirable civil service jobs of the era. On the ground level was a confectionary and ice cream parlor, adorned with a generic striped awning. This stretch of Clinton Street between Delancey and Houston Streets was once known as a popular destination for wedding dress shopping. (Then photograph courtesy of New York Transit Museum.)

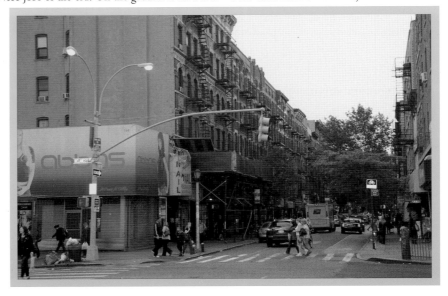

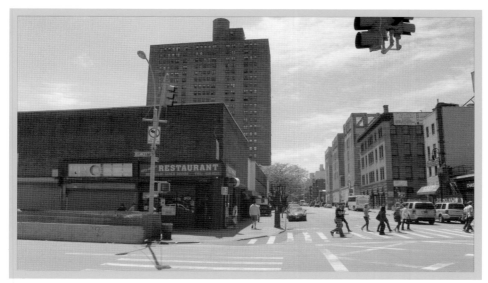

SOUTHEAST CORNER OF ESSEX AND DELANCEY STREETS, 1956. Though still in existence between Rivington and Delancey Streets, the original Essex Street Market stretched three long blocks between Stanton and Broome Streets and occupied three separate buildings. This photograph features the structures that housed the southernmost portion of the market between Delancey and Broome Streets. This indoor market was one of several built in the 1930s by Mayor Fiorello LaGuardia in order to reduce pushcart congestion on the streets. (Then photograph courtesy of New York Transit Museum.)

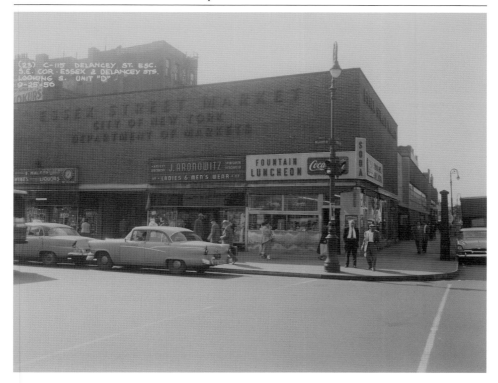

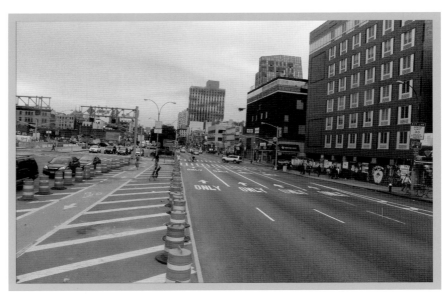

DELANCEY STREET FROM THE WILLIAMSBURG BRIDGE, 1923. This wonderful early-century photograph shows a chaotic scene with trolleys, automobiles, horse and wagons, and pedestrians sharing a stretch of Delancey Street between Clinton and Norfolk Streets. On the right is the Loew's Delancey Theater, located at 140 Delancey Street from 1912 to 1977, and just west of that is the famous Ratner's Delicatessen, occupying 138 Delancey Street from 1918 through 2002. Delancey Street today is barely recognizable from a century ago. (Then photograph courtesy of New York Transit Museum.)

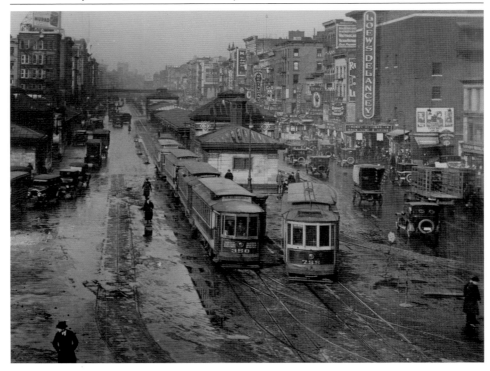

GRAND STREET TO HOUSTON STREET, EAST OF THE BOWERY

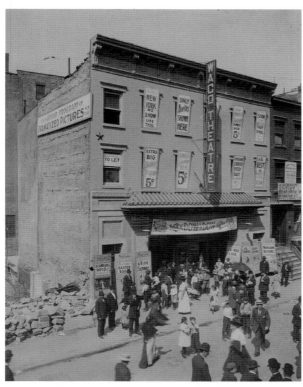

THEATER AT 118 RIVINGTON STREET. Opened in May 1908 at 118 Rivington Street, the Waco Theater gets its name from founding proprietors the World Amusement Company. Originally a 300-seat nickelodeon, the Waco was remodeled into a 600-seat theater by new owners in the 1910s. The venue featured popular live entertainment, as well as movies, well into the late 1920s. (Then photograph courtesy of Cezar Del Valle.)

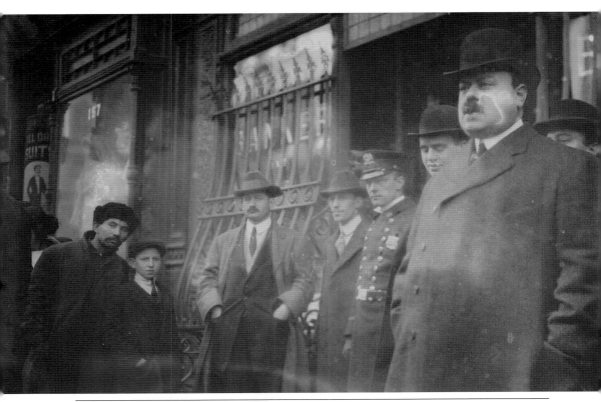

BANK AT 155 RIVINGTON STREET, 1912. This photograph from February 16, 1912, features police standing guard outside of Mendel's Bank at 155 Rivington Street between Clinton and Suffolk Streets. Police were called to the bank to quell a mob when depositors, mostly recent immigrants, panicked and rushed to make withdrawals when rumors spread that the safe had been broken into. Soon after, the address housed a dry goods store, then a garment store, and now it is a bar.

RIVINGTON AT ELDRIDGE STREETS, C. 1910. This view faces west on Rivington Street toward Eldridge Street and beyond to the Third Avenue El on the Bowery, seen in the distance. A large crowd has gathered for the celebration of Jewish New Year, most likely worshippers of the Adath Jeshurun of Jassy congregation nearby. On the left is one the early Carnegie libraries at 61–63 Rivington Street and University Settlement at the corner of Eldridge, which is still in operation.

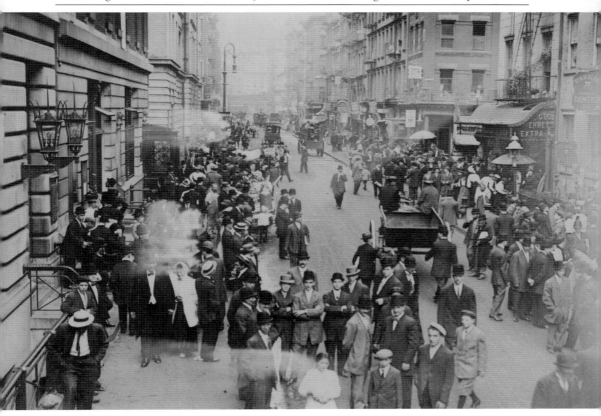

Rivington at Orchard Streets, 1915. This photograph features a view of an unpaved Orchard Street facing south from Rivington Street. Eagle Shoes can be seen on the corner at 85 Rivington, and above that is a dentist's office. Besides the development of a high-rise property on the east side of Orchard Street, this scene is largely unchanged. There have been ornamental changes on the ground floor of 85 Rivington, but remnants of the recognizable brick pattern can still be found.

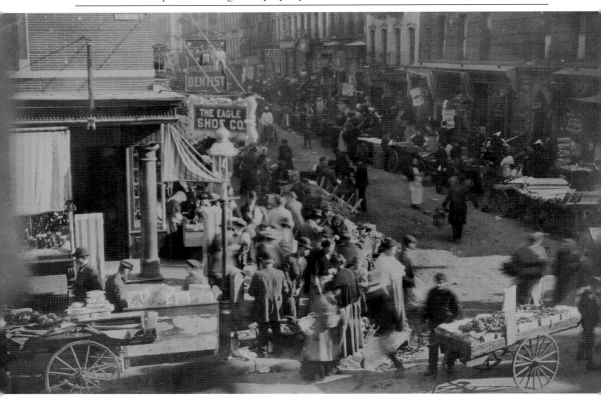

GRAND STREET TO HOUSTON STREET, EAST OF THE BOWERY

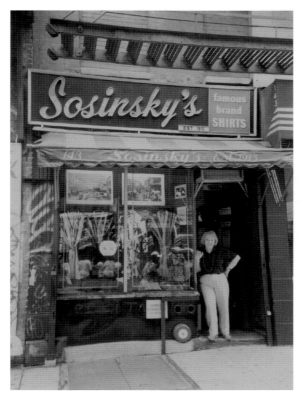

STORE AT 143 ORCHARD STREET, 1995. This photograph features Natalie Sosinsky standing outside of her family-run store at 143 Orchard Street. Primarily a men's clothier specializing in fine shirts, Sosinsky's was established in 1915 by Natalie's father Sam and remained at this location for more than 90 years. Currently, the address hosts a tailor shop. (Then photograph courtesy of Andi Sosin and Joel Sosinsky.)

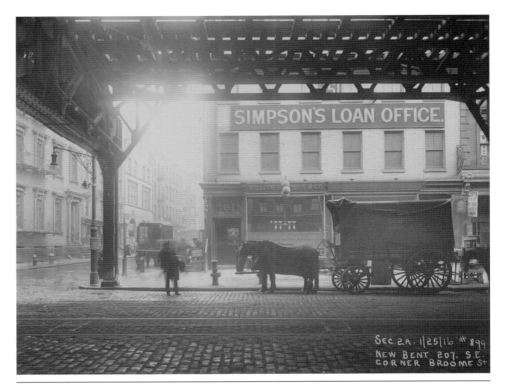

BUSINESS AT 151 BOWERY, 1916. This image features the William Simpson & Company loan office and pawnbrokers at 151 Bowery, on the southeast corner of Broome Street. At this location previous to Simpson's was the notable Nicoll the Tailor, whose popular store took up the entire block from 139–151 Bowery, with outlets across the country—or as old advertisements claim, "branches everywhere." (Then photograph courtesy of New York Transit Museum.)

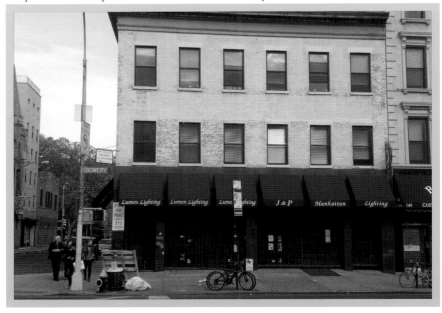

THEATER AT 165–167 BOWERY, 1916. This image shows the exterior of Maiori's Royal Theatre, a prominent 1,500-seat Italian vaudeville theater and opera house operated between 1916 and 1924 by one of the earliest Italian American theater celebrities, Antonio Maiori. Before Maiori took over the theater, this building at 165-167 Bowery was home to Miner's Theater, where vaudevillians like Weber and Fields got their start. The building was destroyed by a fire in 1929 and rebuilt as the Crystal Hotel in 1933. (Then photograph courtesy of New York Transit Museum.)

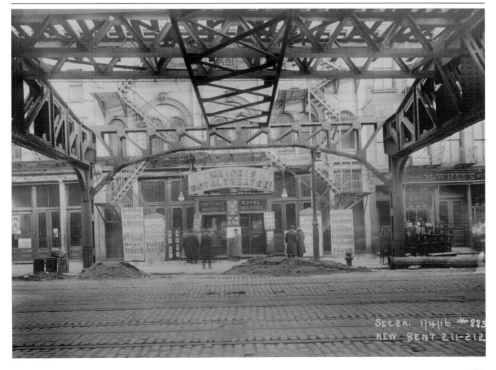

SUPPER CLUB AT 267 BOWERY. Here is a rare exterior image of the world-famous Sammy's Bowery Follies, a unique, raucous supper club once popular with tourists, celebrities, and "Bowery bums" alike. In the late 1930s, proprietor Sammy Fuchs transformed a seedy Bowery dive into a New York City hot spot which lasted, remarkably, until 1970. (Then photograph courtesy Charlie Katz, now photograph courtesy of Shirley Dluginski.)

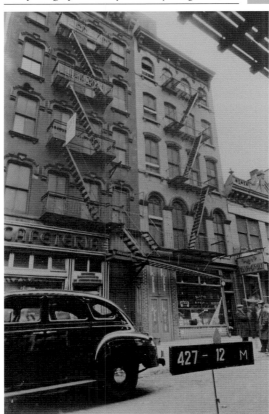

GRAND STREET TO HOUSTON STREET, EAST OF THE BOWERY

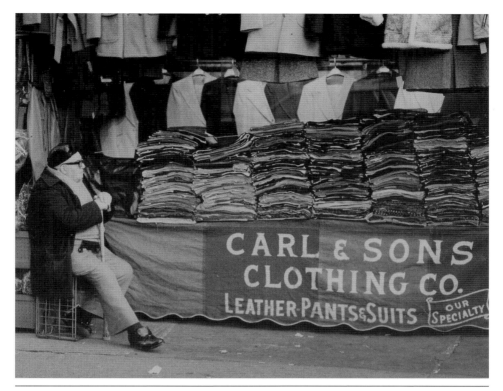

172 Orchard Street, 1970s. In the 1950s, there were five kosher butcher shops on Orchard Street between Stanton and Houston Streets, but by the time this image was captured in the 1970s, they were all gone. Pictured here at 172 Orchard Street on the northeast corner of Stanton Street is Carl's Clothing Store, now occupied by one of hundreds of restaurants in the district. (Then and now photographs courtesy of Paul Weissman.)

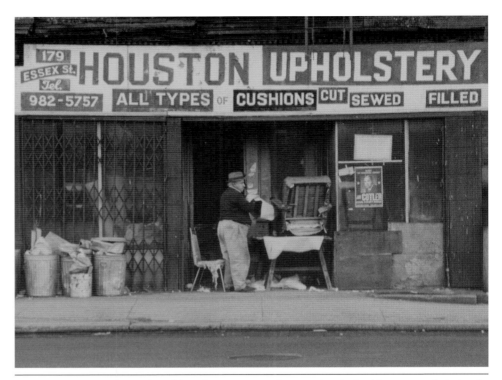

179 ESSEX STREET, 1970S. This address houses a double tenement that is now one of only three residential structures on this once teeming block. When this photograph was taken, Houston Upholstery occupied the ground floor. A man works on what looks like an armchair in the doorway. Currently, a trendy restaurant and a bar occupy the two storefronts of the 179 Essex Street tenement building. (Then and now photographs courtesy of Paul Weissman.)

CHAPTER 5

HOUSTON STREET TO FOURTEENTH STREET

COOPER SQUARE, EARLY 1970S. This bird's-eye view facing south across Cooper Square towards the Bowery was taken from the roof of the Cooper Union for the Advancement of Science and Art. Cooper Square runs only four blocks between East Fourth Street and Astor Place and is named after the founder of Cooper Union, Peter Cooper. Today, the street is undergoing a major makeover with a new traffic pattern and public park planned.

HOUSTON STREET AT ESSEX STREET, 1939. This unique 1939 photograph shows East Houston Street before it was widened in the 1950s. In this eastward view from the corner of Essex Street, the girls' bathroom facility of a public park built in 1909 is visible to the right. This park between Essex and Norfolk Streets still exists, rechristened as the ABC Playground in 1998 after a $250,000 renovation. (Then photograph courtesy of New York Transit Museum.)

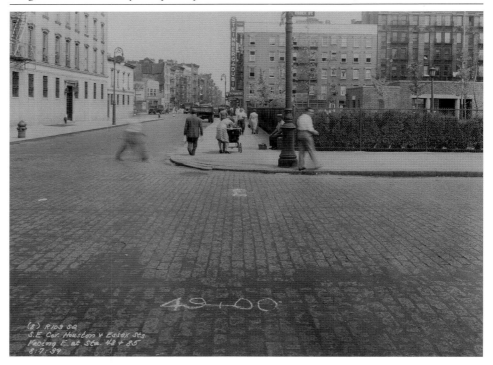

HOUSTON STREET TO EAST FOURTEENTH STREET

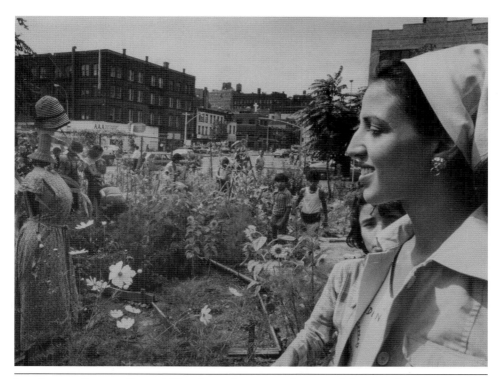

LIZ CHRISTY GARDEN, EARLY 1970S. Originally named the Bowery-Houston Community Farm and Garden when it opened in 1973, this pioneering public space was renamed Liz Christy Garden in 1985 in honor of one of its founders. Christy was part of a group of eco-activists who transformed empty lots around the East Side into green space, conceiving the idea of the community garden. In this photograph, taken in 1973, Christy's Green Guerillas work on the lot at the corner of Bowery and East Houston Street. (Then photograph courtesy of Donald Loggins.)

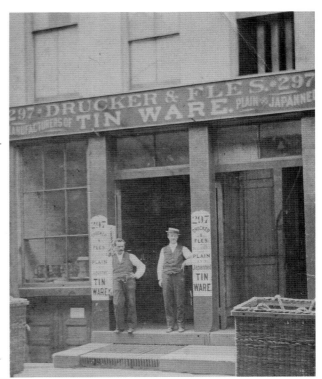

STORE AT 297 EAST FOURTH STREET, 1880s. The Drucker & Fles Tin Ware Store was operated by Isaac and Amelia Fles, in-laws of prominent manufacturer Frederick Haberman, once the largest manufacturer of enameled ware in the world. His factory in Queens had its own Long Island Rail Road station, which closed in 1998. This building was knocked down sometime in the late 20th century, and a community garden has occupied the address since the 1980s. (Then photograph courtesy of Paul Charosh.)

LOCATED AT 290 EAST THIRD STREET. The Boys Brotherhood Republic was founded in Chicago in 1914, but by 1932, a New York branch opened at this address to serve the needs of underprivileged neighborhood children. Alumni include comic book legend Jack Kirby and actor Jerry Stiller. Now known as the Boys and Girls Republic, the institution has since moved to East Sixth Street. Its original address has been remodeled as part of the Henry Street Housing Development. (Then photograph courtesy of Ralph Hittman.)

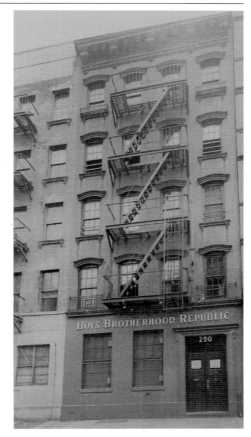

CHURCH AT 173 EAST THIRD STREET, 1875.
The Church of the Most Holy Redeemer was established here between Avenues A and B in 1844 to serve the growing German population of Kleindeutschland. Though originally a modest wooden building, the elaborate cathedral-like construction of today was erected between 1851 and 1852. This 1875 photograph features the original 250-foot tower that was shortened during a 1913 renovation. (Then photograph courtesy of New York Transit Museum, now photograph courtesy of Shirley Dluginski.)

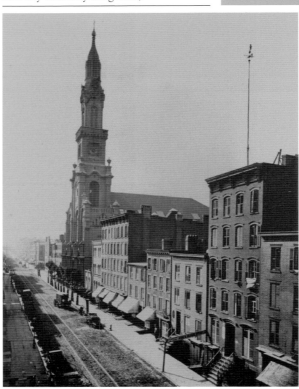

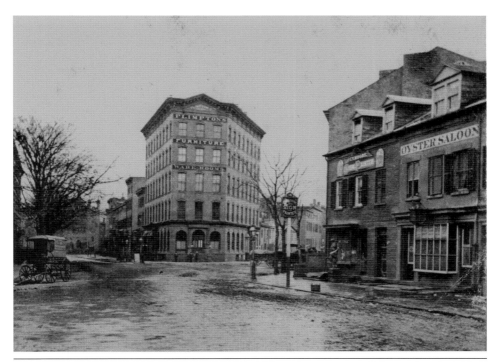

EAST NINTH STREET AND STUYVESANT STREET, 1873. This 1873 photograph shows the somewhat awkward conversion of Stuyvesant and East Ninth Streets facing east from Third Avenue. Stuyvesant Street to the left runs true east-west and is the only local street not redeveloped during the Manhattan street grid plan of 1811; therefore, this one block runs against the modern street pattern. Today, the intersection has been completely redesigned with a small, fenced-in park situated in the triangle. (Then photograph courtesy of New York Transit Museum.)

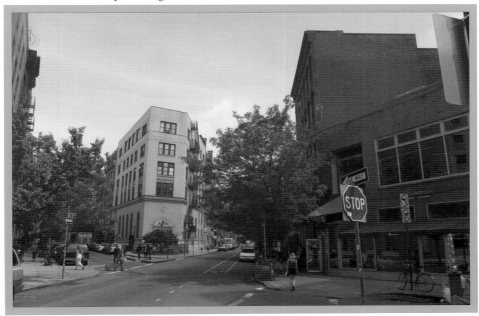

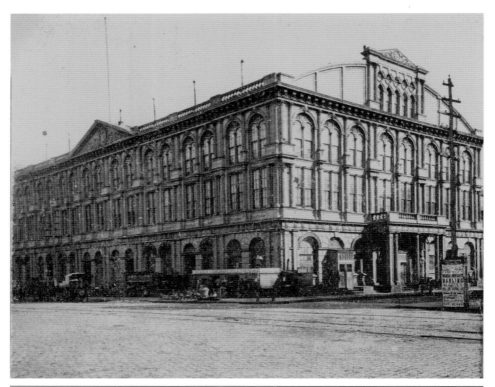

COOPER SQUARE AT EAST SIXTH STREET, 1870. In 1856, as a thank-you for its service during the 1849 Astor Place riot, a new armory was built on the Bowery between East Sixth and Seventh Streets for the 27th Regiment. The second and third floors housed the drill rooms and barracks, and the first floor had an indoor public market named Tompkins Square Market. The Cooper Union recently razed this building, replacing it with the first LEED-standard, environmentally friendly academic building in the city. (Then photograph courtesy of New York Transit Museum.)

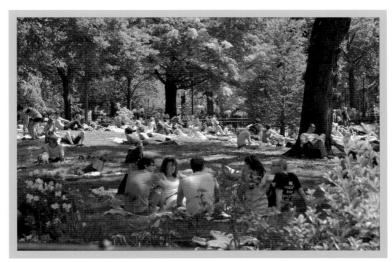

TOMPKINS SQUARE PARK, C. 1915. The 10.5-acre public space opened in 1834 as an amenity to the upper-class population of the era; however, within a few decades, immigrants began flooding the neighborhood, and the park offered an invaluable chance for working-class citizens to take a break from life inside cramped tenements. The park still plays an important role in the quality of life on the Lower East Side. (Now photograph courtesy of Shirley Dluginski.)

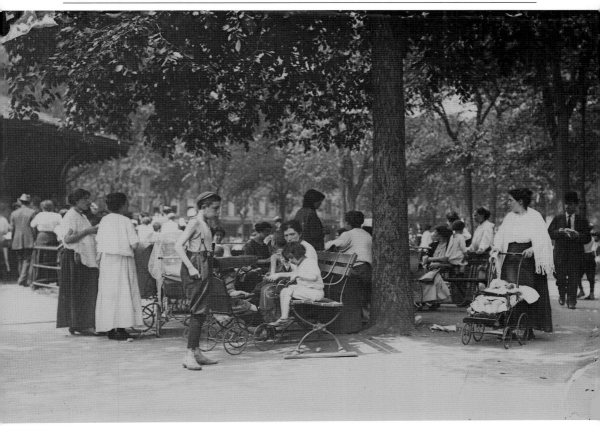

BANK AT 109 AVENUE A, 1914. Known as the "Bank with the Golden Ceiling" because of its elaborately designed interior that included a gold-plated ceiling, Schwenk's Bank served the local Eastern European immigrant community for over three decades. Founded in 1880 in Williamsburg, Brooklyn, the institution was purchased in 1906 by Austrian immigrant, tea importer, and aspiring politician Ladislaus W. Schwenk.

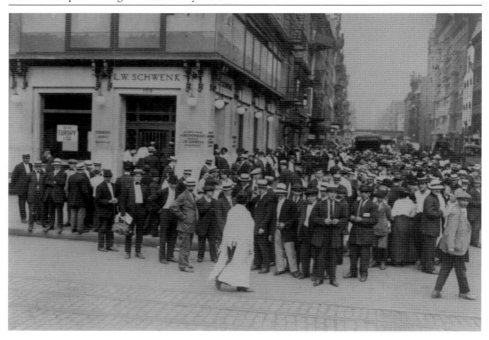

HOUSTON STREET TO EAST FOURTEENTH STREET

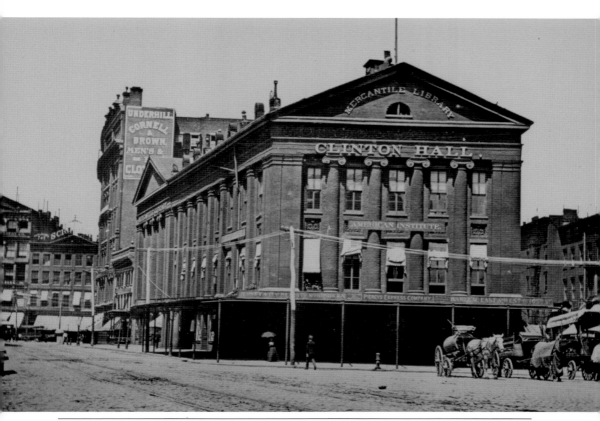

Astor Place, 1886. Clinton Hall, featured in this photograph at the intersection of Astor Place and Lafayette Street, was constructed in 1847 as the Astor Place Opera House; however, after a deadly riot in 1849, the opera house closed, and the New York Mercantile Library moved in. In 1890, this building was demolished and replaced with the 11-story structure of today, which was remodeled into condos during the mid-1990s. (Then photograph courtesy of New York Transit Museum, now photograph courtesy of Shirley Dluginski.)

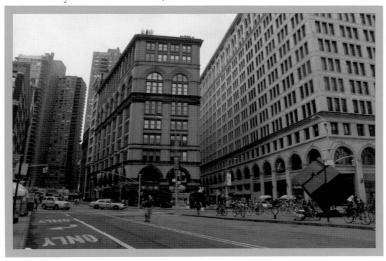

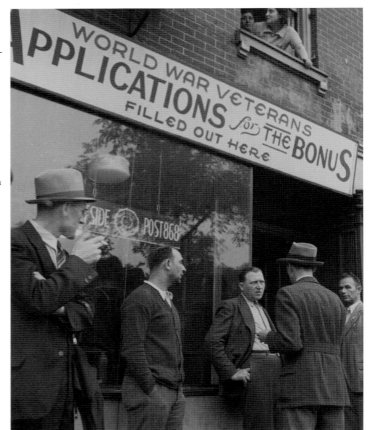

LOCATED AT 164 EAST SEVENTH STREET, 1936. Major Philip Lehman, one of about 75 World War I veterans who founded the American Legion in 1919, opened the East Side Post 868 here at 168 East Seventh Street that same year, with 25 members. Post 868 served the community well into the 1940s and played an invaluable role in the lives of many area working-class men recruited for the war effort. The building, which overlooks the storied Tompkins Square Park, has been exclusively residential since the 1950s. (Now photograph courtesy of Shirley Dluginski.)

**BUILDING AT 347 EAST TENTH STREET,
1980S.** Constructed as a New Law
tenement over a century ago, the Sarah
Powell Huntington Home at 347 East
Tenth Street has assisted homeless women
in the criminal justice system in reuniting
with their families, receiving counseling,
and finding meaningful employment
since 1993. This photograph from the
mid-1980s shows the same building
at the northwest corner of Avenue B
graffiti-ridden and riddled with broken
windows, exemplifying the character of
the neighborhood known as Alphabet
City during the era. (Then photograph
courtesy of David Bellantoni.)

EAST EIGHTH STREET, 1980S. This is another 1980s photograph of Alphabet City, but this time on East Eighth Street between Avenues C and D, a row of empty lots with rubble exists, and garbage is strewn throughout. In the foreground, a fire hydrant runs, and a burned-out van rests a few yards behind it. A large apartment complex has since been built over this site. (Then photograph courtesy of David Bellantoni.)

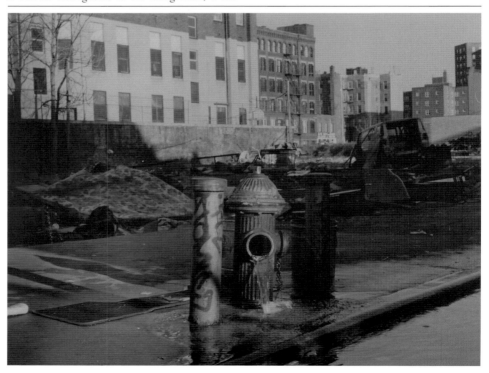

HOUSTON STREET TO EAST FOURTEENTH STREET

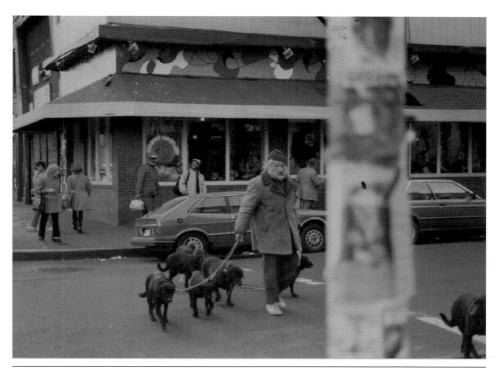

EAST SEVENTH STREET AT AVENUE A, 1980s. Once a fixture in a neighborhood full of characters, Julius the dog walker would be seen each morning strolling through Alphabet City with his caravan of canines. Here, Julius crosses East Seventh Street at Avenue A in front of a restaurant appropriately named 7A, which is still there 30 years after this photograph was taken. One of local artist Jim Power's streetlamp mosaics is in the foreground. (Then photograph courtesy of David Bellantoni.)

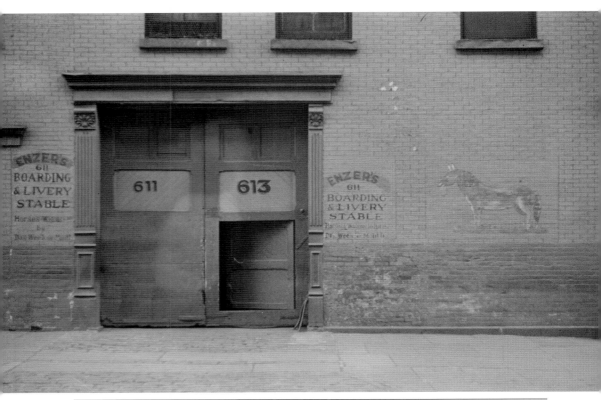

611–613 East Twelfth Street, 1938. The word "Enzer's" is painted over the previous tenant's name on the building's brick facade. The original tenant was John Connolly, undertaker of the historic St. Brigid's Church on Avenue B. This is where Connolly kept his horses and funeral wagons. Today, 611–613 East Twelfth Street no longer exists; the site is used as part of a parking lot for the Campos Plaza apartment complex.

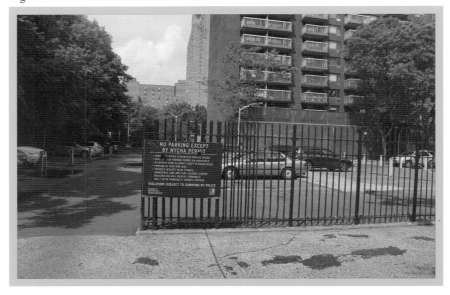

Houston Street to East Fourteenth Street

EAST THIRTEENTH STREET AT THIRD AVENUE, 1911. On November 8, 1911, thousands of city sanitation workers walked off the job, leaving streets virtually barricaded with piles of rubbish, ashes, and horse waste. On the morning this photograph was taken at the corner of Thirteenth Street and Third Avenue, at least a half dozen violent riots broke out across the city, and 5,000 police officers were called upon to quell the unrest. It appears as though a pair of officers is escorting a very brave, strikebreaking street sweeper.

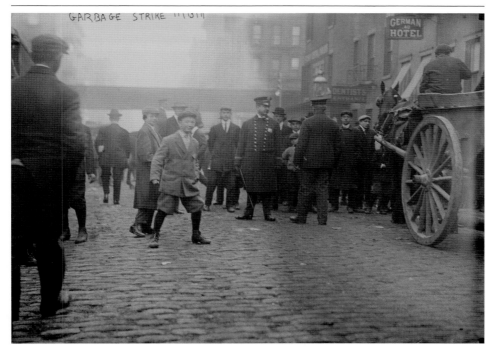

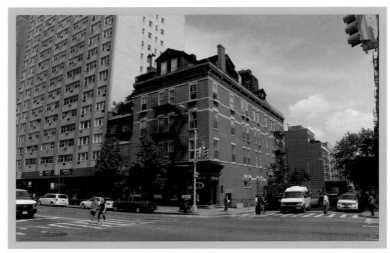

THIRD AVENUE AND EAST THIRTEENTH STREET, C. 1865. The highlight of this mid-19th-century photograph is a once well-known landmark and fixture on the East Side: the Stuyvesant pear tree. New Amsterdam governor Peter Stuyvesant brought the tree from Holland and had it planted in 1664 on what is now the northeast corner of Third Avenue and East Thirteenth Street. In 1867, a carriage accident brought the aged tree down after two centuries. (Then photograph courtesy of New York Transit Museum.)

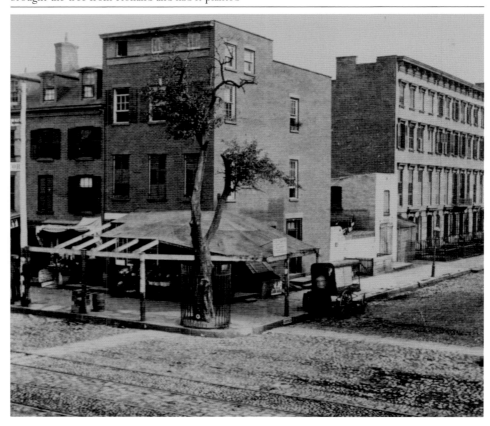

HOUSTON STREET TO EAST FOURTEENTH STREET

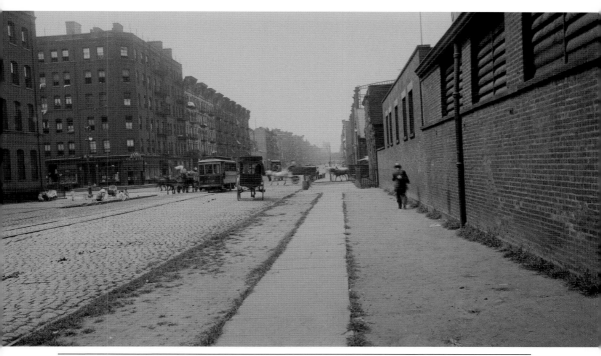

EAST FOURTEENTH STREET AT AVENUE C, 1916.
This is the north side of East Fourteenth Street
facing Avenue C; today, this is the site of Stuyvesant
Town-Peter Cooper Village, a massive 80-acre
residential complex built soon after World War II.
Over 600 apartment buildings, theaters, factories,
churches, stables, and stores were demolished
in the mid-1940s to make way for this sprawling
community that now encompasses the area
between East Fourteenth and Twenty-third Streets,
and First Avenue to Avenue C. (Then photograph
courtesy of New York Transit Museum.)

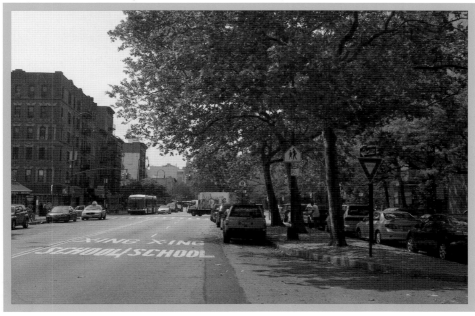

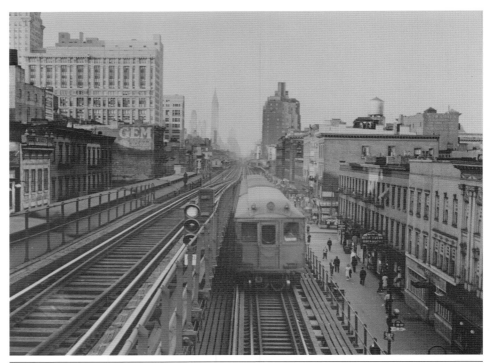

THIRD AVENUE AT EAST TENTH STREET, 1942. The Third Avenue elevated railway, simply known as the El, ran along the Bowery and Third Avenue from City Hall to Gun Hill Road in the Bronx for nearly a century. Constructed between 1875 and 1878, the tracks came down soon after service ended in 1955. This photograph presents a view from the track facing north just below East Tenth Street. Most of the buildings on the right side of this photograph have been replaced with student housing in recent years.

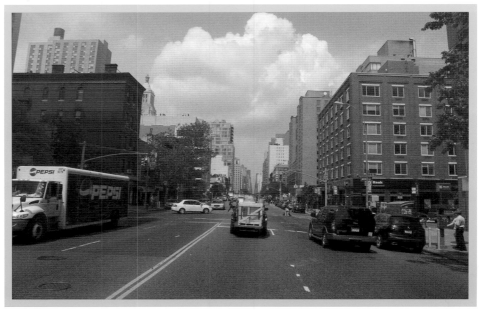

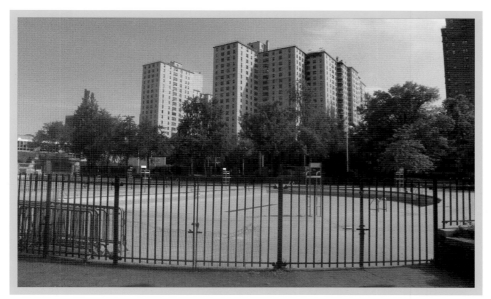

HAMILTON FISH PARK, C. 1900. Designed by Carrère & Hastings, architects of the New York Public Library on Fifth Avenue, the Hamilton Fish Park on Houston and Pitt Street opened in 1900 and has played an invaluable recreational role for residents ever since. In 1903, a running track and tennis courts were added to accommodate more athletic activities, and then in 1936, a swimming pool was installed. In 1992, the park underwent an extensive $14 million renovation, 10 years after its main building was designated a historic landmark.

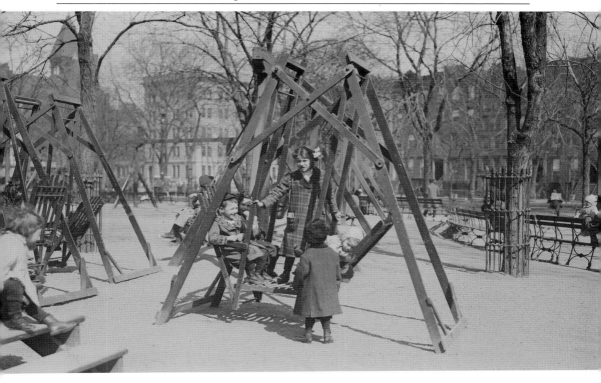

Discover Thousands of Local History Books
Featuring Millions of Vintage Images

Arcadia Publishing, the leading local history publisher in the United States, is committed to making history accessible and meaningful through publishing books that celebrate and preserve the heritage of America's people and places.

Find more books like this at
www.arcadiapublishing.com

Search for your hometown history, your old stomping grounds, and even your favorite sports team.